Camcorder Tricks
& Special Effects

Michael Stavros

AMHERST MEDIA, INC. ■ BUFFALO, NY

Published by:
Amherst Media, Inc.
PO Box 586
Amherst, NY 14226
Fax: (716) 874-4508

Publisher: Craig Alesse
Senior Editor/Project Manager: Michelle Perkins
Copy Editor: Paul Grant
Equipment Photos: Steve Bryant
Illustrations: Michael Stavros and Richard Lynch

Library of Congress #: 98-74717

ISBN #:0-936262-98-2

10 9 8 7 6 5 4 3

Printed in the United States of America.

Acknowledgements

This book is dedicated to Nandi whose loving support and playful encouragement helped make this creation possible. I want to thank Craig Alesse, Richard Lynch, Steve Bryant, Tim Walton and Canon Corporation for their assistance. I also wish to express thanks to all those kind souls who participated in the photographs.

Table of Contents

About Safety...

Most of the tricks and effects in this book involve active participation. As with any activity, take special care to think about the safety of both the people and equipment involved. Children should not attempt to carry out any of the tricks without adult supervision or permission.

Respecting Privacy...

As you venture out into the world with your video camera, respect the privacy of strangers. Use your best judgment when deciding what and whom to shoot. If possible, ask permission before singling out any individual and get that permission in writing if you intend to use the video commercially.

Introduction

Through my career as a video producer and director, I have assembled a wealth of easy, fun tricks and special effects designed for the home videographer. This book contains these illusions and tricks, and explains how to use them.

"... fun tricks and special effects designed for the home videographer ..."

All the effects can be performed without fancy or specialized equipment, using only your camcorder and some items you can find around the house. Each effect is described and explained, and then illustrated by an EXAMPLE. At a glance you can find the minimum number of people you'll need and a lists of the TOOLS & PROPS required. Then, STEP-BY-STEP instructions walk you through the trick. A host of APPLICATIONS suggest creative applications for the technique.

This book contains NO BORING, TECHNICAL JARGON. It's fun reading and will help improve the quality of your home videos. The main objective is to have a good time. A little creativity can go a long way. Don't watch TV, make TV!

Terms You Need to Know

 The number of these icons shows the minimum number of people needed to perform a trick (includes the cameraperson).

TALENT refers to the actor or actress performing or participating in your video.

SUBJECT refers to whatever you're videotaping, usually whatever your camcorder is focused on.

CAMCORDER applies to whatever video recording equipment you may be using.

START refers to pressing the record-pause button to go from pause to record.

STOP refers to pressing the record-pause button to go from record to pause.

PAN is a horizontal camera pivot.

TILT is a vertical camera pivot.

ZOOM IN means to change a zoom lens to a telephoto position.

ZOOM OUT means to change a zoom lens to a wide angle position.

Equipment Tips

To perform these tricks and effects you'll need some basic equipment. At the very least, you'll need a camcorder. You should also consider a tripod, spare battery and lighting equipment.

The Camcorder

A camcorder is actually a combination of a camera and a VCR (video cassette recorder). When you press the record-pause button, your recording unit goes from pause to record ("Start"). When you press the record-pause button again, your recording unit goes back into the pause mode ("Stop").

Many of these tricks require what's known as in-camera editing. This just means planning your shots and shooting in the order you want them. The record-pause button becomes your edit controller. If you shoot something and it didn't turn out the way you intended, you can back up the tape and shoot it again.

If you have access to some sort of editing equipment, you can use it to further enhance your videos, but this requires planning as well. Conventional editing is copying and, each time you edit (or copy), you generate new video. In the video world this is referred to as "going down a generation." Every time you "go down a generation" some quality is sacrificed. Less professional (and less expensive) formats, like VHS and 8mm, lose a noticeable amount of picture quality when they are edited or copied. The advantage to in-camera editing is that you don't lose a generation, therefore you can maintain your first generation image quality.

In order to make your home videos look professional and creative, you need to be familiar with the basic operation of your camcorder. Make sure you understand the white balance system, the fade feature, and other functions and special features for your camcorder. Take a few moments to read these sections of your owner's manual—it will be time well spent.

Tripods & Monopods

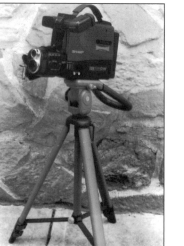

Except for this book, a tripod or monopod is the most important accessory that you can buy for your camcorder. In situations that require a steady shot, a tripod is an extremely useful tool. You can find other innovative methods to steady your camcorder, but none will be as convenient and dependable as a good tripod.

The biggest drawback to a tripod is that it restricts mobility. Where mobility is a concern, you might want to consider a monopod. A

monopod has one leg rather than three. The advantage to a monopod is that you can easily lift it up and move it to a new spot without having to fuss with the legs. The disadvantage of a monopod is that you must hold on to the camera at all times since a monopod is not free standing.

Spare Batteries

Most camera batteries last thirty to forty-five minutes. If you will be shooting longer, you can solve the problem by purchasing a spare battery. By adding just one battery, you virtually increase your battery time infinitely, because you can recharge one while using the other. If you shoot a lot outside, or anywhere that you may find yourself without an AC power source, it might be helpful to have several batteries.

Lighting Equipment

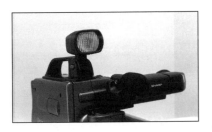

The single most useful piece of lighting equipment is a battery-operated light that mounts onto your camcorder. It won't provide perfect lighting in all situations, but at least you'll never find yourself shooting in the dark. If you are really serious about shooting video, you may want to invest in a lighting kit. They come in a wide variety of configurations and price tags. Professional lighting equipment isn't necessary, but a small light kit can make lighting a little easier.

Adding Sound

Some tricks will be enhanced by adding music or sound effects, either recorded at the time of taping or recorded later. Before you do any dubs, check your camcorder's owner's manual for the best method of recording. You don't always want to use a microphone, and may want to use line-in jacks to connect your sound source directly to the camcorder—depending on the application. Poor audio may subtract from, rather than add to, your project. You can even damage your camcorder or erase the tape if you try to use equipment in a way that was not intended.

Shooting Tips

Knowing how to operate the equipment is important, but you also need to determine what to shoot and how to shoot it. To help you do this, here are some basic shooting tips that will assist you in avoiding some common mistakes.

- **Anticipate the action!**
 Be ready. Don't wait until the cake is lit to get your camcorder, or you'll miss taping "Happy Birthday."

- **Consider lighting before each shot.**
 If the scene is dark or shadowy, add some auxiliary or fill lights.

- **Plan your shots.**
 Know where your shot is going before recording. Check the lighting, framing and focus at both ends of pans, tilts or dolly shots.

- **Hold the camcorder steady.**
 Use a tripod or monopod whenever possible.

- **Use manual focus.**
 Autofocus can be unpredictable and unreliable.

- **Edit the audio along with the visual while recording.**
 For example, don't interrupt a person mid-sentence while filming them.

- **Frame each shot carefully.**
 Don't accidentally cut off someone's head. Try to compose a picture that's balanced and pleasing to look at.

- **Keep shots short and active.**
 Holding shots longer than necessary can create boring video.

- **Pan or tilt slowly and steadily.**
 A bumpy camera move draws attention away from your subject.

- **Don't overuse the zoom.**
 The zoom should only be used intentionally, with purpose. Overuse is the most common amateur videomaking

"... determine what to shoot and how to shoot it."

Simple Trickery

Making things appear, disappear or transform into something else is as easy as A, B, C: just pause the tape, add, remove or change something, and then resume taping. The key is achieving zero camera movement at the moment of "magic".The least camcorder shake will tip off the viewer that there's been an edit. If done properly, the viewer should be asking, "How did you do that?"

Now You See It, Now You Don't

For years characters in the TV programs from *Bewitched* to *Star Trek* have been popping in and out of scenes. Now you can demonstrate your own magic. This effect creates the illusion that a person or object appears or disappears. When the tape is played back, it looks as though magic has occurred.

EXAMPLE:
TALENT A is a magician who performs a magic trick causing TALENT B to vanish.

TOOLS & PROPS:
Camcorder, tripod, two chairs, magic wand

STEP BY STEP:
1. Have TALENT A and TALENT B sit in chairs side by side.
2. Set up your camcorder and lock it down on a tripod. (Hand-holding your camcorder will not work for this trick because there must be zero camera movement.)
3. Frame a wide shot including both people and chairs.
4. Adjust lighting, white balance and focus.
5. Press "start" to roll the tape.
6. Cue the talent.
7. TALENT A speaks: "Welcome, ladies and gentlemen. I will perform some magic and make the person next to me disappear on the count of three. Are you ready? One...two... three..." TALENT A waves a magic wand at TALENT B.
8. Cue the talent to freeze, and press "stop" to pause the tape. TALENT A should remain frozen in position until you give the cue to resume motion. (TALENT A must remain absolutely still.)
9. Ask TALENT B to climb out of the chair and get out of the scene without disturbing anything.

"... make different objects appear and disappear."

10. Press "start" and cue TALENT A to resume motion.

11. TALENT A should look at the empty chair and smile at his/her accomplishment.

12. TALENT A speaks: "Voila, the magic worked!"

13. Press "stop."

On playback, it will appear that TALENT B has disappeared. You may need to practice cuing TALENT A and starting and stopping the tape a few times to get the timing right. Be sure TALENT A doesn't remain frozen on camera after TALENT B "disappears." You can also try reversing the scenario to make TALENT B reappear.

APPLICATIONS:

Once you've got it down you can apply the same principal to make different objects appear and disappear. Incorporate the technique in a script you write yourself, or try to come up with some better dialogue. You might use this trick to show the changes in someone after taking an invisible pill or traveling through a time warp (they might become younger, or older!).

Transformations

This trick creates the illusion that a magical transformation has taken place. This trick can be a lot of fun for children.

EXAMPLE:

A person transforms into another while walking behind a tree.

TOOLS & PROPS:
Camcorder, tripod, a tree with a wide trunk

STEP BY STEP:
1. Find a tree with a trunk wide enough for a person to hide behind.
2. Set up your camcorder on a tripod and frame a long shot with the tree in the center of your frame. Lock the camcorder down.
3. Adjust white balance and focus.
4. Instruct TALENT A to walk from one edge of your frame when cued and stop behind the tree.
5. Press "start" and cue TALENT A.
6. Just as TALENT A vanishes behind the tree press "stop." (Be sure not to move or jiggle the camcorder.)
7. Position TALENT B behind the tree in place of TALENT A, and instruct TALENT B to walk toward the other end of the frame when cued.
8. Press "start" and cue TALENT B.
9. After TALENT B walks from the frame, press "stop."

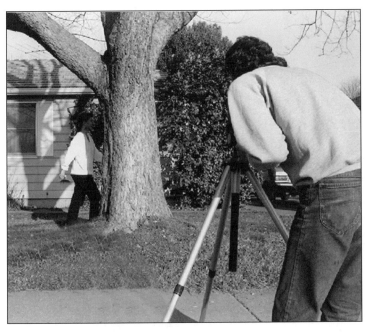

TALENT A will seem to have changed into TALENT B. You may need practice to get the timing down. Ask TALENT B to imitate TALENT A's gait to provide continuity.

APPLICATIONS:
For a slight variation to this trick, use the same person to play both the roles of TALENT A and TALENT B; alter your TALENT's appearance during the cut with a costume change. (*See* "Creating Personalities" on page 52.)

You can use this transformation as an interesting way to indicate the passage of time by making your TALENT appear to have aged. To ensure the viewer understands the change, try adding a sign or graphic to step 8 such as "ten years later."

Simulating Weather & the Elements

Waiting for mother nature to provide what you need can prove inconvenient. The tricks in this section show you how to simulate weather and the elements so you can easily and safely add these effects to your videos.

Rain

Rain may be a necessary part of scene, or it might just add to the mood. You can use the following technique to shoot a rainy scene without waiting for a rainy day.

EXAMPLE:
Use a colander and garden hose to simulate rainfall.

TOOLS & PROPS:
Camcorder, tripod (optional), garden hose, colander, plastic bag

STEP BY STEP:

1. Set up your camcorder and frame a shot of your TALENT. (Lightly spray your TALENT with the mist from a hose for added realism.)

2. To be sure your camcorder is safe, cover it with a plastic bag, and perform the test in steps 3-5.

3. Position the colander in front of and above the lens of the camcorder (one to two feet away). Make sure the colander is out of the frame.

4. Instruct an assistant to slowly run water through the colander to create the rain.

5. When you're sure everything is positioned so that there is no chance of getting your camcorder wet, remove the plastic bag.

6. Adjust white balance and focus.

7. Cue the assistant to pour more water into the colander.

8. Press "start," cue the TALENT, and record the scene.

9. Press "stop."

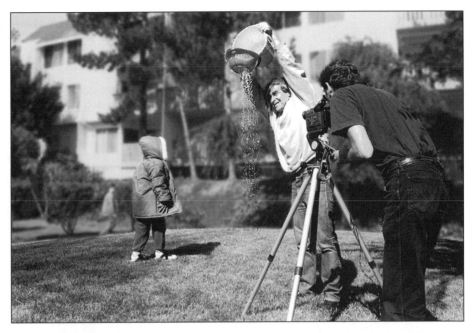

"No one expects amateur video to include effects like weather changes!"

When the tape is played back, the water falling in the foreground will make it look like it's really raining.

APPLICATIONS:

Surprise your audience. No one expects amateur video to include effects like weather changes! Take a bucket and a colander to the beach and use this technique to fake the absurdity of people sunbathing in the rain.

Wind

Wind can have a dramatic and exciting effect on your scene. You can make simple adaptations to add wind to any scene.

EXAMPLE:

Use a fan and leaves to simulate a windy scene.

TOOLS & PROPS:

Camcorder, tripod (optional), electric fan, leaves

STEP BY STEP :

1. Set up your camera, and frame a shot of your TALENT.

2. Adjust white balance and focus.

3. Place a fan just out of the frame.

4. Mess up your TALENT's hair to give it a wind-blown look.

5. Turn on the fan so that it blows toward the TALENT.

6. Press "start," and cue the TALENT.

7. Instruct an assistant to throw leaves in front of the fan so they will blow by the TALENT. This accentuates the visual effect of the "wind."

8. Play the scene and then press "stop."

"Spice up your next mini-adventure movie ..."

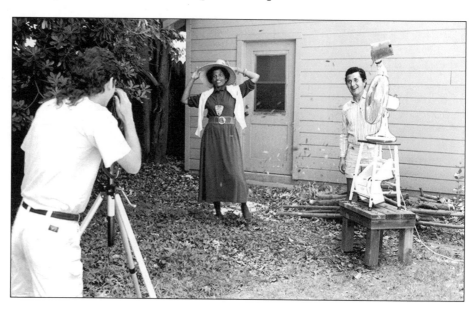

When you play the tape, the movement of leaves and your TALENT's hair and clothing will make it seem as though the wind is blowing.

APPLICATIONS:
Spice up your next mini-adventure movie by adding wind to outdoor scenes to dramatize the action. Try outfitting your TALENT with a lightweight scarf or loose clothing to emphasize the wind's effect.

Fire

This is a safe way to create the illusion that something is burning. You can magnify a relatively harmless fire by placing it in the foreground of the frame, close to the lens and away from your subject.

EXAMPLE:
Use candles in the foreground to engulf your scene in flames.

TOOLS & PROPS:
Camcorder, tripod (optional), candles (or cigarette lighters), a bright auxiliary light, aluminum foil

STEP BY STEP:

1. Set up your camcorder, and frame a shot of your TALENT.

2. Adjust white balance and focus.

3. Place the candles on a step stool or small table between your camcorder and the TALENT. Be sure the candles are close enough to your camcorder to fill the foreground with fire. (If you use disposable lighters, you'll need assistants to hold them.)

4. Manipulate the wicks (or lighters) to produce high flames.

5. Aim a very bright auxiliary light at the shiny side of a piece of aluminum foil and reflect the light onto the TALENT.

6. Have an assistant move the aluminum foil so the reflection simulates the glow of the fire.

7. Light the candles (or lighters).

8. Press "start," cue the TALENT, and shoot through the flames.

9. Play the scene, then press "stop" and extinguish the flames.

On playback, the scene will appear to be engulfed in flames. Don't let the candles or lighters show, and don't let the flame get too close to the lens. That could ruin your camcorder. Don't let anything else catch fire, either. That could ruin your whole day.

APPLICATIONS:

This trick works well when you employ the illusion of scale. Try using a miniature prop, such as a toy truck to create the illusion of an enormous blaze.

Fire Can be Dangerous...

Any type of fire can be dangerous, so before you start this trick, have a bucket of water available. In case something goes wrong, you can use the water to quickly douse the flames.

Shake, Rattle and Roll

If you don't live in California you may never get the chance to capture an earthquake on video. If you do live in California, chances are slim that your camcorder will be on when a tremor strikes. You can, however, create the illusion of an earthquake striking.

EXAMPLE:
Simulate an earthquake striking during a newscast by simultaneously shaking your camcorder and parts of your set.

TOOLS & PROPS:
Camcorder, tripod, table or desk, microphone (if you have one), other news desk props

STEP BY STEP:
1. Choose a location with an appropriate background, and position a table and props so your set looks like a TV news set.
2. Seat your TALENT (newscaster) at the desk.
3. Set up your camcorder on a tripod, and frame your shot to include the TALENT and only the top of the desk.
4. Adjust lighting, white balance and focus.
5. Position an assistant on the floor, next to the desk, out of frame.

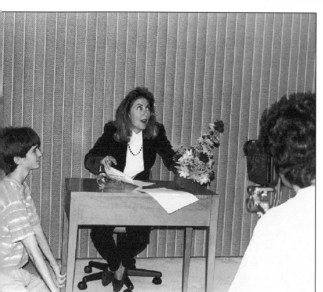

6. Press "start" and cue TALENT to begin the newscast.
7. Twenty seconds into the newscast, cue the start of the quake. The assistant shakes the desk and the TALENT acts terrified. Shake the camcorder so the image jumps around as if the room is moving. How vigorously you shake the camcorder depends on the intensity of the quake you're trying to simulate.
8. Press "stop."

APPLICATIONS:
Variations of the technique used to create the earthquake effect can help simulate other events, such as a space launch, the rumble of a train, or the thundering footsteps of King Kong or a *Jurassic Park* dinosaur. The original *Star Trek* TV series used a similar effect every time the Enterprise took a "hit".

Mobilizing Your Camcorder

Normally, we try to keep our camcorders as still as we possibly can. In order to avoid rough, bumpy shots, we lock the camcorder down on a tripod and let our subject do all the moving. However, by moving the camcorder properly we can also create very professional looking results.

Hello Dolly

A dolly shot is defined as the movement of the entire camcorder as opposed to a zoom or pan where the camcorder stays in the same spot and pivots. However, commercial dolly equipment is financially out of reach of most amateur videographers.

Fortunately, there are many things that can function as creative dolly equipment all around you. It's reported that Don Peterman, director of photography for *Star Trek IV: the Voyage Home*, used a wheelchair for dolly movements. If you don't have access to a wheelchair, you can use a wagon, a grocery cart, a lawn mower, or a golf cart to mobilize your camcorder. Some dolly substitutes are more reliable than others (for example, be sure to take safety into consideration before riding side-saddle on a bicycle holding your expensive camcorder).

EXAMPLE:
Shoot a smooth dolly movement by sitting on an office chair with casters while an assistant pushes you along a marked path.

TOOLS & PROPS:
Camcorder, an office chair with casters (if you can't come up with one, use one of the previously mentioned mobile vehicles; consider using a tripod for the option where it is convenient), lubricant, a smooth floor surface, masking tape

STEP BY STEP:
1. Lube the wheels or casters of your office chair, if needed, so they don't squeak.
2. Determine the path you want your dolly shot to take and tape down some guides to mark the edges of the path. (Masking tape works well and won't harm the floor surface.)

"... make your video unique and professional looking."

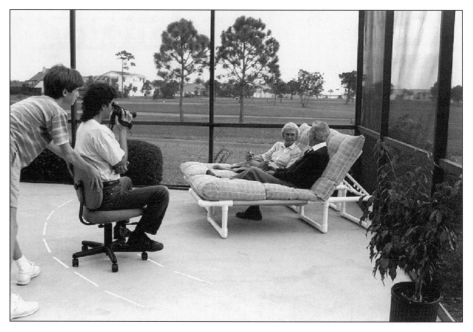

3. Check the path for bumps or other irregularities and smooth them out. This will help keep the shot steady, which is important for a good dolly movement.

4. Position your TALENT: two people on chairs having a serious conversation (scripted or ad-lib).

5. Sit on the office chair and hand-hold your camcorder. (If you are using a substitute vehicle that you will not fit on or in, set your camcorder on a low tripod and kneel next to it.)

6. Adjust lighting, white balance, and focus.

7. Have your assistant push you (in the chair) slowly and steadily along the marked path.

8. Cue the TALENT, press "start" and begin shooting.

9. Press "stop" when you complete your dolly movement.

When the scene is played back, the viewer will see the scene from the vantage point of the moving camera.

APPLICATIONS:

A dolly movement is terrific for focusing attention or creating intensity and adding drama to a scene. The dolly move can be fast or slow. You can move toward the subject, away from the subject, or make a complete circle around. The path you choose depends on the effect you wish to achieve.

Try slowly revolving your camcorder around an actor poised in thought or shoot from a dancer's point of view and make the room spin. A well planned dolly movement can make your video unique and professional looking.

On the Road Again

Videotaping from a moving car can produce exciting shots. You can add even more excitement by enhancing and exaggerating the motion of the car with shooting techniques. You can create the feeling of traveling fast by shooting objects out of the side window rather than through the windshield, or create the illusion of reckless driving by shaking your camcorder a little.

EXAMPLE:
Safely fake a fender bender without putting a scratch on your car.

TOOLS & PROPS:
Camcorder, automobile, some traffic

STEP BY STEP:
1. Find a road where traffic normally moves about 35-45 MPH and frequently stops for lights or intersections.
2. Find an assistant to drive, since you'll be holding your camcorder and shooting from the passenger seat.
3. Aim the camcorder forward to shoot straight out the windshield.
4. Frame a wide angle shot of the car in front of you. Include a little of the hood of your car at the bottom edge of the frame to reveal your vantage point.
5. Adjust white balance and focus.
6. Press "start" and record the car in front of you.
7. As you and the car in front of you slow to a stop, the car in front will appear larger and larger in the viewfinder. At the last moment before actually stopping, zoom in fast on the back end of the car in front and shake the camcorder as if you've hit.

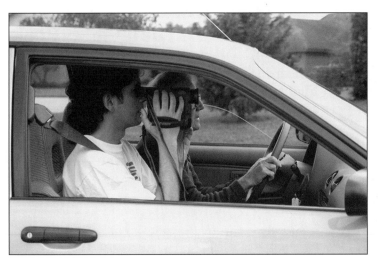

8. Press "stop."

When you play back the tape it'll look as though you came to an abrupt stop and crashed into the car in front of you. Add screech and crash sound effects to make the effect even more realistic. (*See note* "Adding Sound" on page 7.)

APPLICATIONS:
Next time you're videotaping from a moving car, try this effect to add dramatic action to your journey. If you're feeling ambitious, consider making your own mini movie complete with the classic car chase.

Creating Sets

"... create believable sets by planning convincing foregrounds and backgrounds."

Your camcorder is limited by its inability to portray the same view we see with our eyes. The creative videographer can use this to an advantage. After all, when people watch a video, they can not see a panoramic view. This makes it easier to mislead or trick them, since they will make assumptions about what is outside of the frame. You can exploit this limitation and create believable sets by carefully planning convincing foregrounds and backgrounds, and adding appropriate props to fool a viewer.

A quick and easy way to create an illusion is by using a realistic poster for a background. It's important to choose something large enough to fill the entire frame. If the poster you use is of an African jungle, have your TALENT put on a safari hat and stand in the foreground. With simple adjustments, it can look as though the TALENT is really standing in the jungle in front of elephants, or monkeys, or whatever. Sheets, blankets, and curtains can also create effective backgrounds. Hang them from a pole to avoid wrinkles and sags.

Another option is to use careful framing to create an illusion. A tight shot of a local sandy beach could look like the middle of the Sahara Desert—if you don't show the water or the sunbathers. A close-up of your TALENT in front of a couple of thick trees could trick viewers into believing a scene was taken in the forest.

You probably pass by hundreds of potentially useful backgrounds every day. It's helpful to keep a list of these potential spots as you notice them. Whatever setting you'd like can be within your grasp, if you take the time to get creative in mixing foregrounds and backgrounds to create the scene you want.

Jailhouse Rock

You can set up your camcorder at your local jail if you want to tape a jail scene, but you might stay longer than you had hoped if you don't get proper permission. This trick offers an easier method.

EXAMPLE:
Use an oven rack and the right background to create the illusion that your scene takes place in jail.

TOOLS & PROPS:
Camcorder, tripod, a relatively clean oven rack, a cot, a small table, cell props

"Use this
fun effect to
introduce a
new 'friend' to
your parents ..."

STEP BY STEP:

1. Find a wall to use as a background (cement or cinder blocks work great, but any plain wall will do). Add props to make the scene look like a bona fide jail cell.

2. Set up your camcorder on a tripod facing the wall from about ten feet away.

3. Dress your TALENT in a blue work shirt (or something that will look like a prison outfit), and position him/her facing the camcorder, about halfway between it and the wall.

4. Have the TALENT grip the edges of the oven rack with both hands and hold it straight out toward the camcorder lens. Make sure the bars are positioned vertically.

5. Frame a shot of the TALENT through the bars of the oven rack. Be sure to fill the frame with the rack, keeping the edges out of the frame.

6. Adjust lighting, white balance and focus.

7. Press "start," cue TALENT, and record your jail sequence.

8. Press "stop."

Done properly, the foreground and background illusion will convince your audience that they are viewing the TALENT through the bars of his/her jail cell.

APPLICATIONS:

Use this fun effect to introduce a new "friend" to your parents, describe how you feel about your job, or create a spoof about the government.

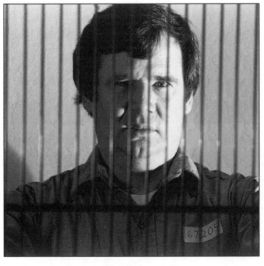
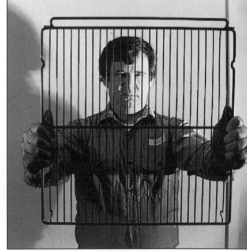

SPECIAL EFFECT

10

Instant Restaurant

To shoot a restaurant scene, it would be best to shoot inside a real restaurant. For the purpose of this example, let's say you can't. You can still use the outside of a restaurant to spark an illusion, and then create a simulation of the inside. With attention to detail, you can create any atmosphere you choose.

EXAMPLE:
Create a "real" restaurant by effectively manipulating backgrounds and settings.

TOOLS & PROPS:
Camcorder, tripod, restaurant front, table and props (such as a table cloth, candles, salt and pepper shakers, napkins, menus, glasses), waiter/waitress costume

STEP BY STEP: (In Two Parts)

Part 1

1. Select a restaurant and TALENT (A&B).

2. Set up your camcorder on a tripod outside the restaurant, and frame a shot of the front entryway. Include a sign or something that makes it recognizable as a restaurant.

3. Adjust white balance and focus.

4. Cue TALENT A&B to walk into the restaurant.

5. Press "start" and record as they walk up and enter the front of the restaurant.

6. Press "stop" and turn off your camcorder.

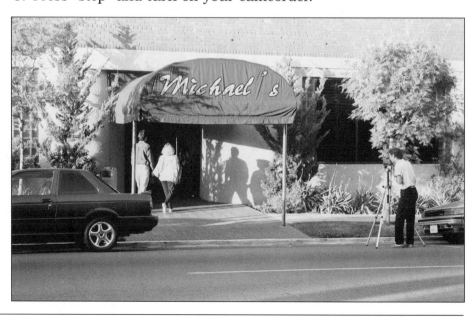

Part 2

7. Now create the restaurant interior. Look for a room with an appropriate background. Your kitchen won't work unless you hide the appliances and cabinets.

8. Make your chosen location look like a restaurant: set the table, place some nice chairs, and add other props.

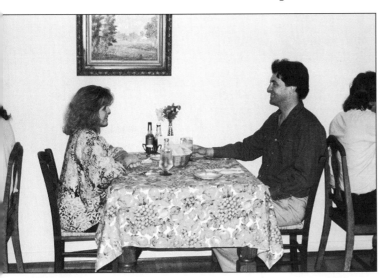

9. Set up your camcorder on a tripod and frame a shot of the table. Be careful to show only the background that helps suggest a restaurant atmosphere.

10. Adjust lighting, white balance and focus.

11. Dress TALENT C as a waiter or waitress, and instruct him/her to seat TALENT A&B (the same people you used in steps 1-6) when cued.

12. Press "start," and cue the action.

13. Press "stop" when the scene is over.

On playback, your audience will believe that the scene takes place in a restaurant you used as a backdrop in Part 1. To make the restaurant illusion even more credible, involve additional talent as customers and employees. Keep in mind that you only need to worry about what is in the frame.

APPLICATIONS:

Use similar deceptions to add realism to your sets: shoot the outside of your local hospital for a hospital scene, or take an outside shot of the county jail to add to your prisoner sequence in the previous trick, JAIL-HOUSE ROCK. In the same way you can create a museum, a library, or an airport waiting area.

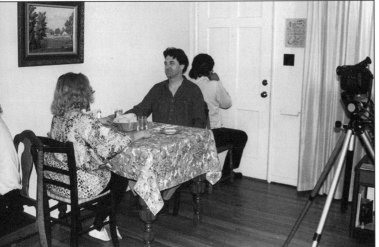

Projected Background Illusions

If you have access to a slide projector, a projected image can provide you with a wonderful, large background. This trick takes some experimentation and patience because it can be a little tricky to light, but the results can be well worth the trouble.

EXAMPLE:

Create a setting using a projected image.

TOOLS & PROPS:

Camcorder, tripod, slide projector, screen, two auxiliary lights, cardboard

STEP BY STEP:

1. Pick a slide of an appropriate background (don't use anything that contains people, animals, or anything that would normally be moving).

2. Set up the projector, and project the slide onto a screen (use a white wall or a white sheet if you do not have a screen).

3. Set your camcorder up on a tripod about fifteen feet from the screen, and five to ten feet to one side of the projector. (*See diagram below*.) You will be shooting the screen at an angle.

4. Fill the frame with the screen image.

5. Dress the TALENT appropriate to the setting portrayed by the slide image.

6. Position the TALENT between your camcorder and the screen, so that the TALENT does not block the projection.

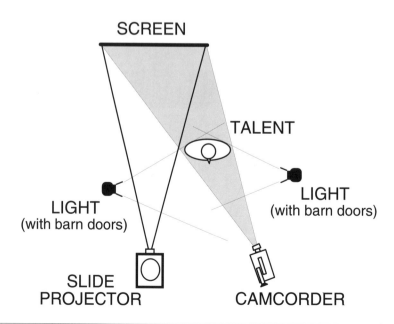

7. Position an auxiliary light on each side of the TALENT to compensate for the backlighting caused by the projected image. Be sure the lights are out of the frame.

8. Shield the light to prevent it from spilling onto the background and washing out your slide image. Use barn doors (light shields) or cardboard sheets as deflectors. Adjust and readjust your lighting and deflectors until your subject is lit sufficiently without affecting the slide in the background.

9. With the lights on, adjust white balance and focus.

10. Press "start," and tape your TALENT in his new reality.

11. Press "stop."

If done correctly, on playback it'll appear that your TALENT is actually at the scene you have chosen.

APPLICATIONS:

Use this trick to make your next family gathering appear to be in some exotic location, or add more realism to other tricks in this book. For example, try using a slide from your last trip to Europe to create the background for MAKE A FOREIGN FILM (page 31). Have fun dressing up and playing the role that matches your backdrop. (See "Creating Personalities", page 52.)

"... make your next family gathering appear to be in some exotic location."

Animation

The purpose of animation is to bring motion to an otherwise inanimate object. We generally think of animation as requiring thousands of drawings or movements shot frame by frame. These methods take a lot of time or a lot of money, so few consider animation for home videos.

However, there are methods that simulate animation which you can use to spice up your videos. With a little thought you can make objects animate and have a whole lot of fun in the process. If you have children, they will especially enjoy the tricks in this section.

Simply Animated

One way to animate objects is to move them manually without pausing the camcorder. Of course, this is not real animation like you are used to seeing in a cartoon, but it's easy and it works. The methods are like techniques used in puppet shows and many old science fiction movies.

For example, you can maneuver an object by holding on to a part of it that extends just outside the frame. If you are unable to hold the object without being seen, try holding it with thread, fishing line, a coat hanger, a black glove or anything that will blend in with the background (you can adjust the lighting to help hide your animation aids). The important thing is not to let your audience see how you are moving the object.

EXAMPLE:
Create a science fiction scene with a model UFO.

TOOLS & PROPS:
Camcorder, tripod, poster (or other background image), thread, model UFO (if you don't have a model, use cardboard and draw a flying saucer)

STEP BY STEP:
1. Choose a background (like a poster of the New York City skyline or the Golden Gate Bridge), and tack it to a board.
2. Set up your camcorder on a tripod, and frame a shot so the picture fills the viewfinder.
3. Adjust lighting, white balance, and focus.
4. Take some thread (choose a color that'll blend with the sky) and

tie it neatly to the top of your UFO. Clip any excess.

5. Instruct an assistant to hold the thread above the upper edge of the frame and use it to move the UFO. across the sky.

6. Practice a few times, and adjust the lighting so that the thread is less visible.

7. When ready, press "start" to begin your scene.

8. Press "stop" when the scene is over.

"...a great opportunity for you and your children to create a story."

When you play this scene back, it should look as though the UFO is flying across the sky under its own power.

APPLICATIONS:

This is a great opportunity for you and your children to create a story. Gather a few miniature toys and write a short script around them. If you're not into UFOs, use this same technique to gallop horses across the prairie in a mini-western, or race two toy cars in a "cops and robbers" adventure. The possibilities are limitless. You probably won't be able to create animation that competes with Disney, but then again, Disney doesn't have to work within your budget.

SPECIAL EFFECT # 13

Motionless Motion

A technique akin to traditional animation can be accomplished by a process of repeatedly stopping the camcorder, moving an object slightly, and starting the camcorder again. All you'll need for this to work is an object to move, and a gullible audience.

EXAMPLE:
Make an ordinary chair appear to hop across a room by moving it while the camcorder is in the pause mode.

TOOLS & PROPS:
Camcorder, tripod, a chair

STEP BY STEP:
1. Get a chair – a light one. You're going to move it a zillion times.

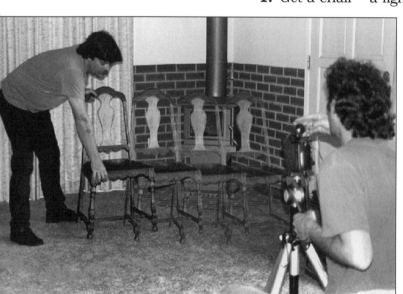

2. Set up your camcorder on a tripod in a large room and frame the widest shot possible, then lock down the camcorder.

3. Place the chair at one end of the frame and choose a path for it to travel.

4. Adjust lighting, white balance and focus.

5. Press "start."

6. Leave the tape rolling for about two seconds and press "stop."

7. Move the chair about two inches in the direction you want to make it travel and roll the tape for two more seconds.

8. Keep repeating step 7 until the chair ends up at the other end of the path.

When you playback the tape, it will appear that the chair has traveled on its own.

Keep the camcorder perfectly still between moves. Depending on the size of the room and the timing of your camcorder, you may need to adjust the distance you move the chair and/or the number of seconds you let the tape roll between moves. Do a trial run with five moves, then play back the tape to see if it's working.

APPLICATIONS:
This easy trick lets you add a little life to a normally motionless object. Make a stuffed animal walk across a bed. Line up children like a train and make them seem to chug across the yard without moving their feet. Try this technique to create your own magic.

Camcorder Timing

Each camcorder operates a little differently and sometimes exact cuing can be difficult. To determine your camcorder's timing, frame the face of a moving clock and press "start" when the second hand reaches 12. Then, press "stop" when the hand reaches the 12 again. When you play back the segment, you can see just how long it takes your camcorder to start and stop. Do this several times in succession, and you can see exactly how much the camcorder adjusts the tape between stops and starts. Practice taping the clock so that the motion of the second hand appears uninterrupted from shot to shot.

Sound Ideas

Our eyes and our ears usually work together as a team. We see what we see, we hear what we hear, and from that we figure out what's going on. You may not be able to see Canadian geese, but you know they're overhead when you hear them. You'll pull your car off to the side of the road when you hear a siren, even if you don't see a fire truck, ambulance, or police car. It's this trusting relationship between the eyes and the ears that allows us to create a whole range of illusions on video by simply manipulating the audio.

Audio Illusion

It can be difficult to fool a sophisticated audience with visual deception alone (as in NOW YOU SEE IT, NOW YOU DON'T on page 9). Audio effects can add credibility to the visual deception.

EXAMPLE:
Use audio to reinforce the illusion of magically making your TALENT disappear from inside a box.

TOOLS & PROPS:
Camcorder, tripod, large cardboard box (large enough to fit a person inside)

STEP BY STEP:
1. Place a cardboard box on your set.
2. Set up your camcorder on a tripod at least ten to fifteen feet from the box.

3. Position TALENT A and TALENT B standing next to the box.

4. Frame a wide shot to include the TALENT (A&B) and the box.

5. Adjust lighting, white balance, and focus.

6. Press "start" and cue the TALENT.

7. TALENT B speaks: "And now, ladies and gentlemen, I will make my assistant climb into this box and disappear."

8. TALENT A climbs into the box while TALENT B watches.

9. With TALENT A in the box, press "stop" and cue TALENT B to freeze.

10. Instruct TALENT A to climb out of the box and stand off camera, being careful not to move the box or TALENT B.

11. Press "start" and cue TALENT B to resume.

12. TALENT B speaks: "Are you comfortable in there?"

13. TALENT A (outside the frame) should muffle his/her voice as if still in the box and answer: "I'm fine but it's a bit dark in here."

14. To complete the illusion, TALENT B does the abracadabra thing, exposes the empty box and declares that TALENT A has vanished.

15. Press "stop."

Hearing the muffled voice makes the viewer believe that TALENT A is still in the box up to the moment he/she disappears. The viewer will be genuinely surprised when the box is revealed to be empty.

APPLICATIONS:

Use this same concept to create other audio illusions. Convince your audience that your TALENT is inside a sugar bowl, trapped in the trunk of a car, or on the other end of a telephone conversation. Make a doll talk, make a stuffed animal growl, or videotape your house pets and create voices for their thoughts.

SPECIAL EFFECT # 15

"... make your video appear to be a foreign film that has been dubbed in English."

Make a Foreign Film

It seems that many people are intrigued with foreign films. Maybe it's the pace or the scenery, or maybe it has to do with the common belief that anything made thousands of miles away has got to be good.

If you wanted to make a foreign film, you could hire a foreign production crew, or you could use TALENT right from your own backyard and fake it. You won't actually be able to shoot in front of the Eiffel Tower or on top of the Great Wall of China, but if you incorporate some of the tricks in CREATING SETS you can make your scene look as if it were taped somewhere exotic.

However, as soon as your American TALENT opens their English speaking mouths, the authenticity of the foreign set you created will be lost. The solution to this problem is to make your video appear to be a foreign film that has been dubbed in English.

EXAMPLE:
Fake dubbing your scene using two sets of TALENT: on-camera "foreign" TALENT (who silently mouth gibberish), and off-camera American TALENT (who will read the lines in English).

TOOLS & PROPS:
Camcorder, tripod, a good background

STEP BY STEP:
1. Write a script for the scene you want to shoot.
2. Find or create the appropriate background to make your foreign location look authentic.
3. Pick your "on-camera" and "off-camera" TALENT (CAST A and B, respectively). CAST B should match CAST A in number and gender. Match up partners for each role, one from CAST A and the other from CAST B.
4. Give all TALENT a copy of the script. CAST A need not memorize the lines, but they need to understand the general idea of what's going to be said and what gestures and movements to make; they will act out all the mannerisms and movements their role requires, but they will not speak aloud. Instead of speaking, CAST A should silently mouth the words as though speaking a foreign language, or gibberish. CAST B's job is to say the lines in English, just off camera, while CAST A mouths the words and does the acting.

5. Let your TALENT practice the timing of the dialogue and actions. Start with something simple.

6. When the TALENT seems ready, set the camcorder up on a tripod, and frame the scene.

7. Adjust lighting, white balance and focus.

8. Position CAST B outside the frame, but as close to the camcorder's microphone as possible.

9. Press "start" and cue TALENT (CAST A and B) to play the scene.

10. Press "stop" when the scene is over.

"All you need is fun-loving, willing TALENT and a little creativity."

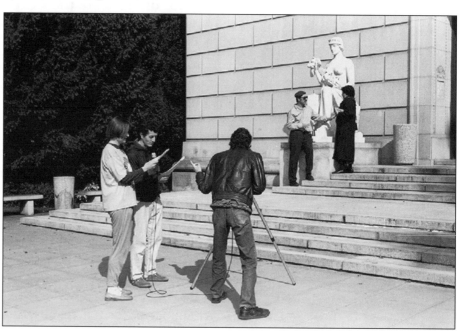

If everybody's timing is right, when you play back the tape it should appear as though the English was dubbed into your "foreign" film.

APPLICATIONS:

This comical effect is great fun at parties. All you need is fun-loving, willing TALENT and a little creativity.

If your camcorder has an audio dub feature, you can also try a variation of this trick by dubbing over an existing movie or TV program. Start by taping a movie or program on your VCR, then make up new words to create your own story or satire. Dub this new dialogue into the program, replacing the original dialogue. The new dialogue will be out of lip sync and it'll appear that the program was first recorded in a foreign language and then dubbed in English.

Fun with Focus

In most situations, you want to achieve the sharpest focus possible to achieve a good video picture. However, there are instances when you might purposefully deviate from this rule. In this section, we demonstrate two very distinct techniques that use focus adjustment artistically.

Transition Focus

You can use changes in focus as a way of connecting two shots, like a fade or wipe. Using focus manipulation can help you make one shot actually appear to dissolve into another without complex editing.

EXAMPLE:

Use focus manipulation to make a smooth transition between shots of different tables at a wedding reception.

TOOLS & PROPS:

Camcorder, tripod (optional), an invitation to a wedding

STEP BY STEP: (In 2 Parts)

Part 1

1. Shoot the table of the bride's friends. After you've spent some time shooting, press "stop."

2. Do a trial run for the next shot (step 4). While remaining in pause, frame a long shot of the whole table. Steadily zoom in to the floral centerpiece and near the end of the zoom slowly turn the focus ring to achieve a blur. This trial run is important so that you can determine where the zoom will end up, when to start turning the focus ring, and which direction on the focus ring will bring the image to the desired blur. When you feel comfortable with it, proceed to the next step.

3. Frame your long shot again.

4. Press "start" and begin shooting, repeating the shot you practiced in step 2.

5. When you've achieved the blur press "stop."

"... make one shot actually appear to dissolve into another ..."

6. To complete the transition, run over to the table of the groom's friends.

7. Frame a shot of the centerpiece starting out-of-focus, and zoomed in all the way.

8. Do a trial run for the shot in step 9. Practice slowly bringing the image into focus as you zoom out to a long shot of the whole table.

9. Once you've got it, frame the out-of-focus shot in step 7 again, press "start" and perform the shot you just practiced in step 8.

10. Press "stop."

11. Finish off the sequence by shooting similar shots at the table of the groom's friends as you did in step 1.

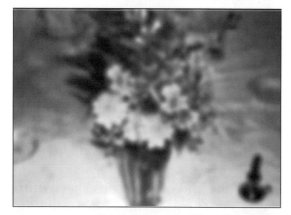

When you play the tape back, it should look as though you've zoomed into the floral piece at one table and, through the magic of video, zoomed out to another table. Again, whenever you're zooming or changing focus on tape it's a good idea to practice the shot first so you'll know what it will look like before you start.

APPLICATIONS:

Like a fade, changing focus can also signify a change in place or time. Use this effect for all kinds of transitions. Go out of focus on a painting to change rooms, or blur on a door to go inside. Go from one person to another, or from one day to the next. Try using this effect to introduce a dream sequence.

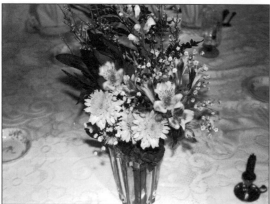

SPECIAL EFFECT # 17

Selective Focus

Instead of keeping everything in the sharpest possible focus, you can select one object to focus on and keep the rest of the picture in soft focus. The idea is to focus on something in the foreground while leaving the background out-of-focus and then manipulating the focus ring to bring the background into focus while letting the foreground go out of focus. This draws the viewer's attention to the portion of the picture that's in sharpest focus.

Of course this won't work if both the foreground and background are in sharp focus at the same time. The key to successfully accomplishing this effect is to have a shallow depth of field. Without getting too technical, depth of field is the distance between the closest and farthest area of the frame that will be in focus at the same time. There are three principles that determine depth of field. They are:

- The greater the lens opening (or, the less light on the subject), the smaller the depth of field.

- The shorter the distance between the camera and the subject, the smaller the depth of field.

- The longer the lens (zoomed in all the way to a close-up), the smaller the depth of field.

Therefore, if you're trying to create a small depth of field, use low lighting, don't get too far away from what you're shooting, and shoot it zoomed in (telephoto).

EXAMPLE:
Redirect the viewer's attention from a teacup to a teapot by manipulating focus.

TOOLS & PROPS:
Camcorder, tripod, table, teapot, cup

STEP BY STEP:
1. Set up your camcorder on a tripod about five or six feet from your kitchen table.

2. Adjust lighting and white balance.

3. Place a teapot at the far end of the table and a teacup at the end closest to the camcorder.

4. Position your camcorder so that it's in a straight line with the two objects, and lock the camcorder down on a tripod.

"... select one object to focus on and keep the rest of the picture in soft focus."

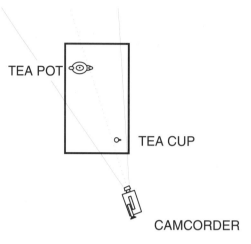

5. Re-position the cup one inch to the right and the teapot one inch left of center frame. The cup should not be blocking the view of the teapot. (See diagram and photo.)

6. Zoom in all the way (or pretty close to it) and frame a shot of the teapot and the cup.

7. Manually focus on the cup. The teapot should be in the background, out-of-focus.

8. Press "start"; record for a few seconds.

9. While still recording, turn the focus ring until the teapot comes into focus. The teacup will go out-of-focus and all but disappear.

10. Turn the focus ring to bring the cup back into focus and lose the tea pot.

11. Press "stop."

"... redirect the viewer's attention ... by manipulating focus."

On playback, the tea pot will appear out of an obscure blur in the background, drawing the viewer's attention away from the disappearing tea cup, and vice versa.

APPLICATIONS:

This can be a very dramatic effect. You can take advantage of this principle and draw the attention of your audience to various objects by changing the focus. Try this technique with people and use it to coordinate their dialogue.

Framing Deceptions

To make good videos, it's necessary to think beyond the limitations of reality—don't rule anything out until you've considered all the possibilities. When a viewer watches a video, they make assumptions about what they are seeing. You can exploit this fact to create illusions that will impress even the most jaded viewer.

Phony Split Screens

Usually a split screen refers to two separate images from two different cameras electronically lined up side by side on one screen. You can, however, use the natural split between two distinct backgrounds to create the illusion of an electronic split screen.

EXAMPLE:
Simulate a split screen with two people talking to each other on the telephone.

TOOLS & PROPS:
Camcorder, tripod, wall with two distinct backgrounds, black pole or thick wire (optional), non-matching furniture, two telephones

STEP BY STEP:
1. Pick a wall with a vertical separation, such as where wood paneling meets sheet rock, where drapes meet a wall, or where a fire place ends.

2. Set up your camcorder on a tripod and frame a shot with the separation of the two backgrounds running vertically down the center of the screen. You can enhance the split screen look by placing a black pole or thick wire along the separation.

3. Create contrasts in the sets on each side of the separation. Use furniture, wall hangings and other props to make each side look different than the other.

4. Position TALENT A and TALENT B in the frame so that one is in front of each background.

5. Give each TALENT a telephone prop.

6. Adjust lighting as necessary to make sure shadows don't cross the vertical separation, which would give away the trick.

7. Adjust white balance and focus.

8. Instruct the TALENT to talk to each other on the telephone as if they were miles apart and talking to one another on the phone.

9. Press "start," cue the TALENT, and watch the split screen fun.

10. Press "stop."

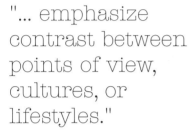

"... emphasize contrast between points of view, cultures, or lifestyles."

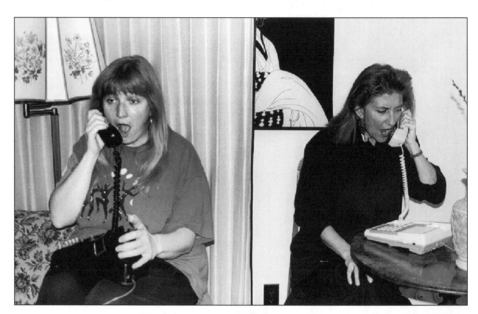

When you play back the tape, it will seem that the two people on the screen are conversing from miles apart.

APPLICATIONS:

You can use this split screen effect to show two people thinking about each other, or perhaps to simulate a satellite broadcast interview. You can also use the side-by-side nature of the split screen to emphasize contrast between points of view, cultures, or lifestyles.

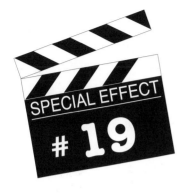

Defy Gravity

By tilting your camera sideways you can change what the viewer perceives as "up," and your TALENT can seem to climb the walls. The important thing to remember in this trick is gravity; watch for things that might tip off the viewer. For example, be sure your wall-walker isn't wearing dangling earrings. If you'd like, you can add props to support the notion that a floor is the side of a building, such as a rope for the climber.

EXAMPLE:

In this example, create the illusion of someone scaling a wooden wall.

TOOLS & PROPS:

Camcorder, tripod, wood deck, climbing rope

STEP BY STEP:

1. Find a large wood deck to use as your wall.

2. Set up your tripod so the tilt lever is off to the side, 90 degrees from your subject.

3. Mount your camcorder on the tripod so that the camcorder is facing your subject (the deck). When you operate the tilt lever, the camcorder should tilt from side to side.

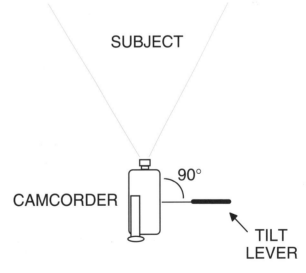

4. Move the tilt lever all the way up so the camcorder is tilted on its side.

5. Frame the shot of the wood deck to make it look as much like a wall as possible.

6. Adjust white balance and focus.

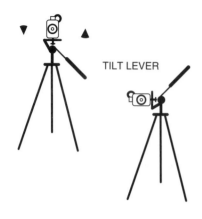

TILT LEVER

7. Instruct your TALENT to lie face down on the decking, and pretend to climb up the deck as if it were the side of a building. Make sure the TALENT is properly framed.

8. Adjust the background and props to eliminate any clues that show the effect of gravity. For example, you won't be able to convince your viewer that the deck is the side of a wall if your cat is sleeping on it.

9. Practice a few times until the positioning and action look realistic.

10. Cue the TALENT to start climbing and press "start."

11. Press "stop" when the climb is over.

By positioning your camcorder on its side, the perspective will appear to shift by 90 degrees. When you playback the tape your climber will appear to be defying gravity by climbing up the side of a wall.

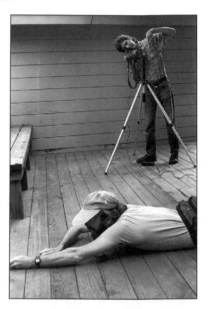

APPLICATIONS:

Use this clever illusion to create your own *Cliffhanger* sequence for your mini-action video. Or, use this effect to create a comedy gag. For example, you could pull back to a long shot to reveal the sleeping cat (referred to in step 8). Your confused viewer will quickly realize the error of assuming a wall to be a wall.

"... your climber will appear to be defying gravity ..."

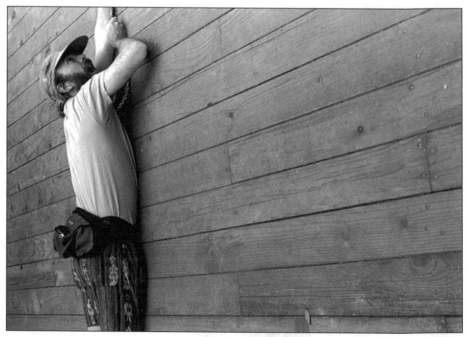

Titling

Most movies and books have a title or distinguishing name, so why not your home videos? Not only are your videos worthy of such definition, but a title can be an integral component and a precious addition.

If you want your videos to stand out and have a professional look, you need to be creative with titling. For example, you can write your title in sand at the beach and shoot it as the tide washes it away. At home, type your title into a computer and shoot it on the monitor or as it comes out of the printer. Paint your title on the back of an old tee shirt, get some chalk and write it on your driveway, or arrange your title with letters from a Scrabble™ game.

If you're shooting a wedding, an invitation makes a terrific title shot. If you're videotaping a birthday party you could shoot the message on the cake or the "Happy Birthday" sign hanging at the front door, and follow that up by zooming into the date on a calendar. For your vacation perhaps the "Welcome to Hawaii" sign will do. For a children's story, you could scribble the title in crayons. For a steamy love story, how about writing the title on a fogged up window? A person writing the title on a blackboard or pad of paper can provide a dramatic title, or a note on the refrigerator door might create the mysterious title you're looking for. If you can gather a crowd, each person could hold up a flash card to reveal the title. The following tricks show other ways of using titles creatively.

Clever C.G. Titles

Many newer camcorders come equipped with built-in character generators (C.G.'s). They are wonderful and easy to use, but they can also be quite limiting. You may only get two letter sizes and probably only one letter style, or font. After a while, all your video titles will start to look the same and probably not too different than the titles your neighbor is using.

But you can still use the character generator in your camcorder to make creative titles. It's an excellent start and can easily be enhanced by picking a title idea that's consistent with your theme. For example, you can produce a very interesting title by displaying character generated letters over a carefully created background. Simply enter your title into the character generator, display it over an intentional out-of-focus shot of an appropriate scene, then focus the shot and lose the title.

EXAMPLE:

Use the above technique when shooting your child's little league game, and call the video "BATTER UP."

TOOLS & PROPS:

Camcorder with a built-in character generator, tripod

STEP BY STEP:

1. Input the appropriate title into your character generator.

2. Set up your camcorder on a tripod.

3. Frame a close-up of the TALENT standing by the door with his or her baseball cap.

4. Adjust lighting and white balance.

5. Make sure your camcorder is set on manual focus, and adjust the focus ring so that the TALENT is totally out-of-focus.

6. Activate the fade function and press "start" to fade up and begin recording.

7. Hit the appropriate button to bring up the title which was input in step 1.

8. Keep the title over the blurry background long enough to read it comfortably.

9. Remove the title and, at the same time, quickly but steadily turn the focus ring to achieve a sharp focus and reveal the TALENT's smiling face.

10. Press "stop." Go on to film highlights of your child at the game.

"Your viewers will be hooked."

When you playback the tape, you'll see the title, "BATTER UP," over an unrecognizable background. As your child's smiling face comes into focus, the title disappears. Your viewers will be hooked.

APPLICATIONS:

The words "OUR VACATION" won't look so boring if they're superimposed over a shot through the front window of your car as you zip down the highway. If your video is about your dog, try displaying the title over a shot of the dog house. Consult VIDEO FEEDBACK (on page 57) for other ideas on how you can manipulate C.G. titles.

Title Sheets

Autofocus can also be used to produce an exciting special effect for titles. You can layer titles so that when one is whisked out of the way, another quickly sharpens into focus. Generally you shouldn't give up manual focus, but in this case autofocus is very handy.

EXAMPLE:

Slide a word collage of your title out of the way to reveal and focus on the title standing alone.

TOOLS & PROPS:

Camcorder, tripod, two poster boards (or large sheets of paper)

STEP BY STEP:

1. Design the title of your video in the middle of a poster board or large sheet of paper (sheet A).

2. Now, design another title sheet (sheet B). Try creating a pattern by repeating the words from sheet A (*see photo*).

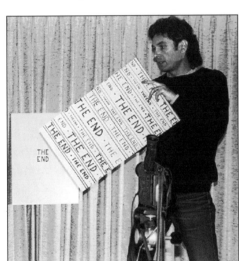

3. Hang sheet A on the wall.

4. Set up camcorder on a tripod about ten feet from the wall.

5. Zoom in and frame a shot with the title on sheet A centered.

6. Set your camcorder to "autofocus," so it automatically focuses on sheet A.

7. Hold sheet B up halfway between the wall and camcorder, blocking sheet A. The autofocus will focus on sheet B.

8. Press "start" and begin shooting sheet B.

9. Pull sheet B out of the way, revealing sheet A. The autofocus will adjust to pull sheet A into focus.

10. Press "stop" when you've given your viewer enough time to read the title.

The pattern will fly out of the way as the title suddenly appears. Try moving sheet B faster or slower. If necessary, adjust the distance between the camcorder and the wall.

APPLICATIONS:

Experiment with different titles and designs. Instead of designing your own title sheet B, look around for existing patterns such as wrapping paper, a painting, or a poster. For example, if your video title is "My Vacation" you can use a road map as sheet B. If your video is some sort of news event, you could pull a newspaper across the screen. This trick can help emphasize the program's theme and grab the viewer's attention right from the onset.

Wipeout

In video terms, a "wipe" is an effect used to make a transition from one shot to another. You've seen many wipes on television: an image is pushed off the screen horizontally, vertically, diagonally, or in another pattern, as it makes way for a second image.

A simple wipe can be simulated by moving a door or board with a title on it to reveal your talent and the scene.

EXAMPLE:
Introducing "Bob" with a title on a sliding door.

TOOLS & PROPS:
Camcorder, tripod, sliding door, a sign

STEP BY STEP:

1. Find a sliding door. If no door is available, substitute a piece of plywood or poster board.

2. Set up your camcorder on a tripod about four feet from the door.

3. Frame the widest shot possible, without revealing the edges of the door.

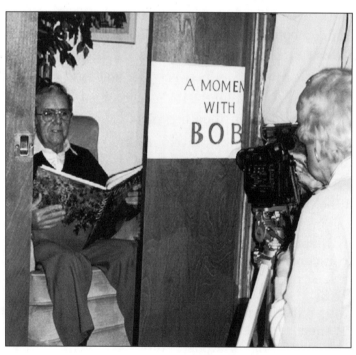

4. Hang a title sign on the door in the middle of your frame. For this example, it can read "A Moment with Bob."

5. Set up your TALENT (Bob), in a chair behind the door, so that when the door is opened the camcorder will be framed on him.

6. Adjust lighting, white balance and turn the autofocus on so it will automatically adjust when the door is opened.

7. With the door closed, press "start" and shoot the title sign for five seconds.

8. Cue an assistant to slide the door to one side until it is out of the frame and the TALENT is in full view.

9. Cue TALENT.

10. Press "stop" when the scene is over.

When the tape is played back, the movement of the door will look similar to an electronic wipe. The title will appear to be pushed off the screen by the live image of "Bob."

APPLICATIONS:

Use this effect to introduce segments or to make transitions from one scene to another. Look around your house for other wipe possibilities, such as garage doors, cabinet doors or window shades.

If you want to try something a little more complex, use a sliding door with a mirror on it (or just slide a mirror by hand). Consult the trick called "Little Window" for tips on how to set up an image in a mirror. When you slide the mirror out of the way, the live image on the mirror will wipe to your scene.

Un-digital Titling

You've seen titles zip in and out and spin all around on television. Those are all digital effects, requiring costly, sophisticated equipment. In this trick you can achieve almost the same effect by zooming, tilting and panning away from a title simultaneously.

I sometimes call this trick a cheap digital effect. Don't think that "cheap" implies that it's not a good quality trick; this trick won't break, sag or damage easily. It won't run out prematurely and it won't leave you stranded. I call it "cheap" because it won't cost you a penny. You'll need a camcorder with a manual zoom or a very fast power zoom.

EXAMPLE:

Simulate a digital effect that makes a title zip across the screen.

TOOLS & PROPS:

Camcorder, tripod (optional), poster board

STEP BY STEP:

1. Design your title on the poster board. Choose color, style, and other elements to make it interesting. Your title can be as simple or detailed as you'd like, but keep it within a two inch square in the upper left portion of the poster board.

2. Hang the poster board on a wall.

3. Set your camcorder up on a tripod about four feet from the poster board. (You can hand-hold your camcorder if you prefer.)

4. Zoom in and frame a shot of the title.

5. Adjust lighting, white balance and focus.

6. Press "start" and begin shooting the title.

7. Zoom out, tilt down, and pan right toward the bottom right corner of the poster board. Watch through the viewfinder to be sure

the title moves steadily toward the top left corner while shrinking before exiting the viewfinder.

8. Press "stop."

"... the title should zip out the corner of the frame ..."

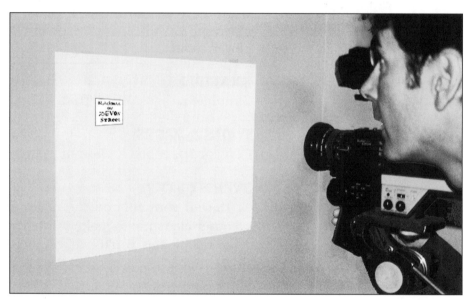

On playback, the title should zip out the corner of the frame in a wild curvy path as it shrinks away.

APPLICATIONS:

This effect is a great way to produce a wild-looking title, and results get better with practice and experimentation. It's perfect for science fiction movies or rock videos. You can really wow your audience and spice up even the dullest titles. Try this trick hand-held: the added camera movement can change the whole look.

Working with Words

In video, words play an intricate role. Words are used to create scripts; they are written on the screen for titles, credits and direction; and they are spoken to make up much of the audio. This section contains some ideas to help you use words effectively, playfully, and interactively with TALENT and audience.

Word Play

You can fool your audience into believing that the letters made by the character generator are actually floating in the air, by allowing your TALENT to interact with letters and words.

EXAMPLE:
Make the TALENT appear to blow out the word "FIRE."

TOOLS & PROPS:
Camcorder, tripod, TV monitor, character generator

STEP BY STEP:

1. Set up your camcorder on a tripod.

2. Set up a TV monitor next to your camcorder so that the TALENT will be able to see him or herself as well as the characters (words) that you'll be putting up on the screen. (*See diagram.*)

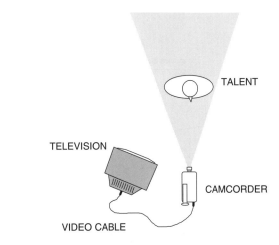

3. Input the word "FIRE" into the character generator. Don't center the word. Enter it to one side of the frame.

4. Take the word off the screen.

5. Press "start" and cue the TALENT.

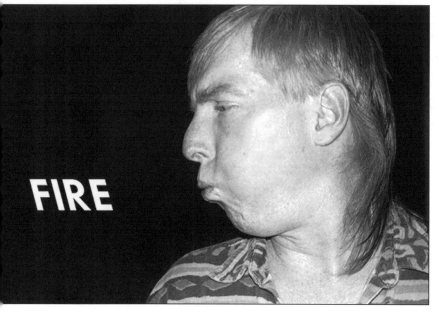

6. The TALENT should look at the camcorder and give some type of presentation.

7. Pop the word "FIRE" back onto the screen.

8. The TALENT should abruptly stop talking and turn toward the word and blow at it.

9. Just as the TALENT blows, press the appropriate button on your character generator to remove the word.

10. Press "stop."

When you playback the tape, it should appear that your talent has blown out the "fire."

APPLICATIONS:

Try this concept with different words and different situations. Perhaps your TALENT could turn and eat the word "food" or reach out and catch the word "bug" (or if you want to try and gross out your viewers, you can have your TALENT eat the word "bug"). Or how about making a question mark (?) appear over the head of TALENT while he is intently thinking. You can try putting up letters that spell words when read from the TALENT's perspective like: TAHW (WHAT), OTUA (AUTO), or TON (NOT). You can make it look as though your TALENT is actually reading the words. At very least, your audience will be confused. Try this fun effect at a party, or interact with your favorite words in the privacy of your own home.

Homemade TelePrompTer

Newscasters can deliver the news without looking as though they're reading because of years of training, practice, and an expensive TelePrompTer. You can build your own less sophisticated, but very adequate, TelePrompTer to help your talent deliver their lines.

EXAMPLE:
Build a homemade teleprompter out of household materials to help your TALENT with their lines.

TOOLS & PROPS:
Camcorder, tripod, cardboard (heavy and light), duct tape, wooden dowel (1$\frac{1}{2}$ feet long), scissors, paper, marker

STEP BY STEP:

1. Cut two circles $1^1/_2$ feet in diameter from the heavy cardboard.

2. Make a hole in the center of each circle.

3. Stick the dowel through the center of both circles, leaving 1 foot between the circles and three inches of dowel at each end.

4. Cut out a strip of light cardboard 1x5 feet. (This should be light, flexible cardboard.)

5. Wrap the light cardboard strip around the two circles, and secure it with duct tape. Overlap the end, forming a cardboard cylinder. This is the basic structure for your TelePrompTer.

6. Tape several pieces of paper together and write your script on it. Make sure to write large enough for your TALENT to read.

7. Wrap the script around and attach it to the the TelePrompTer wheel.

8. Have an assistant grip the wheel by the dowel ends and hold it under the camcorder lens.

9. Turn the wheel so the first line faces your TALENT.

10. Frame your shot of the TALENT, making sure that the TelePrompTer is out of the frame.

11. Adjust lighting, focus and white balance.

12. Press "start" and cue your TALENT.

13. Your assistant should turn the TelePrompTer wheel as your TALENT reads the script, matching the TALENT's pace.

14. When the segment is completed, press "stop."

When you play back the tape, your TALENT's eyes will be focused as if he/she is looking directly into the camera, instead of reading from the TelePrompTer.

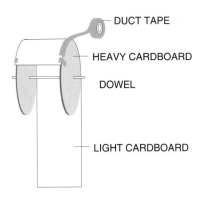

DUCT TAPE

HEAVY CARDBOARD

DOWEL

LIGHT CARDBOARD

APPLICATIONS:

No matter what you're shooting, your homemade TelePrompTer can come in handy anytime your TALENT needs help remembering what to say. After all, even world leaders need a few prompts once in a while.

Scrolling

You have undoubtedly seen credits scrolling up the screen at the end of a movie—unless, of course, you are that person who charges for the parking lot as soon as the last line of dialogue is spoken. You can create scrolling titles, credits or prologues for your home videos and you don't have to buy fancy equipment. Instead of moving the words electronically, you can move your camcorder manually.

EXAMPLE:
Videotape words that scroll up the screen, using typed pages and a tripod.

TOOLS & PROPS:
Camcorder, tripod, typewriter, typing paper

STEP BY STEP:

1. Type whatever it is you want to scroll on a long sheet of paper (tape several sheets together, or use perforated computer paper). Leave wide margins to create a long narrow format for the credits, and leave enough extra space at both the top and bottom so the ends of the page will not be revealed.

2. Set your camcorder on a tripod and aim it at a wall.

3. Hang your scroll sheet on the wall in front of the camcorder, and line it up so that it's centered and straight.

4. Move your tripod's pedestal all the way up and secure it so the first line of the credits are just below the frame. (If your tripod does not have a pedestal feature you can tilt down the page slowly to achieve almost the same result. See "About the Tilt Method" on next page.)

5. Frame a shot with the top of the scroll sheet centered, filling the frame.

6. Lock down the pan control so the camcorder doesn't swivel from side to side.

7. Adjust lighting, white balance and focus.

8. Press "start" and begin to slowly pedestal (or tilt) down.

9. When you reach the bottom of the scroll sheet, press "stop."

On playback, the words will appear to scroll up the screen.

About the Tilt Method

As you tilt down the page, the distance between the lens and the paper will change slightly and this may cause some minor problems. The perspective will be a little off and part of the page may be a little out of focus. If you notice a slight focus problem, try using the autofocus. If that doesn't work, you can still correct the problem by forming a gentle curve on the scroll sheet. The idea is to form the curve so that the camera lens will be exactly the same distance from the top of the page as it is from the middle and the bottom during the tilt. Practice step 8 and adjust the curve of your scroll sheet until the focus looks right.

Creating Personalities

An old expression states "The clothes make the man." The premise is that we create an illusion of who we are by how we appear. Certainly who we really are goes a lot deeper than how we look, but by manipulating our outer appearance we can play different roles. This concept is a natural match for video, which itself can be a medium of illusion. A little make-up in the right place can give your character personality.

With an inexpensive make-up kit you can paint on freckles and moles. You can even paint on a black eye or a scar. If a scenario has your TALENT running from his/her pursuers and you need to make him/her look sweaty, dampen his/her brow with baby oil. If you wish to give someone that rough unshaven look, rub cold cream into his face to make it sticky and then sprinkle on some coffee grounds for an instant beard. You can change the shape of someone's face by putting cotton balls inside his cheeks, as was done with Marlon Brando in *The Godfather*.

Making Up Is So Much Fun

Suppose you need to portray an elderly man in your video, yet your TALENT is only twenty or thirty years old. In order for your video to be effective, you and the TALENT must convince the audience of his elderly status. In short, he must look and act his age. Surprisingly, these two goals are linked. Creating the appropriate visual image for your TALENT will aid his ability to perform the role appropriately.

EXAMPLE:
Make your TALENT look as old as his own father or grandfather by changing his hair to an elderly shade of gray with flour.

TOOLS & PROPS:
$^1/_2$ cup flour, towel, eye liner

STEP BY STEP:
1. Take your victim—I mean TALENT—and half a cup of white flour and go outside (doing this indoors can make a bit of a mess).
2. Cover your TALENT with a towel from the neck down.
3. Sprinkle a little flour on your TALENT's hair. Don't add too much flour at one time, as it's easier to add more than to remove it.
4. Gently rub the flour deep into the TALENT's scalp as if you were washing his/her hair.

5. Stand back and take a look to determine if you need to add more flour.

6. Continue to repeat steps 3, 4 & 5 until you get the desired gray look.

7. Carefully do the same to the eyebrows to turn them a matching gray. If your TALENT has a beard or mustache, make those gray as well

8. Wipe off any excess flour.

9. With an eye liner, lightly accentuate or create some wrinkles on the forehead and at the corners of the eyes.

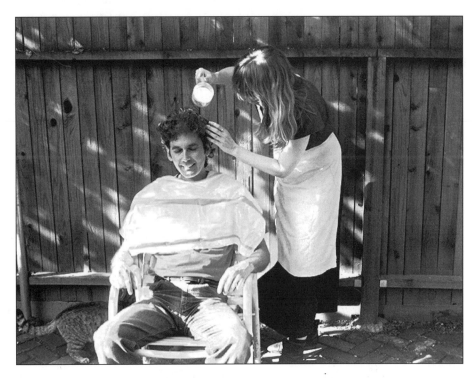

When you are finished, you will have transformed the TALENT into a much older looking person.

APPLICATIONS:

Make-up and costumes aren't just for Halloween anymore. Try altering your TALENT's appearance whenever your video calls for a "character." In addition to making your audience believe, the right costume and make-up helps the TALENT to play their roles better.

About Talcum Powder

You could use talcum powder instead of flour, but if you do, be sure to warn your TALENT not to breath it in: breathing talcum powder is not good for you.

Light

The effect of lighting depends on the quantity, quality, and direction of light. By manipulating each of the variables, you can achieve whatever look you need.

Lighting can give your scene a natural, realistic appearance, or it can create a look that is surrealistic or unusual. Low, tinted light can add a romantic feel, while back light can be dramatic. Shadows can be used to indicate where the light is coming from, imply the existence of something off camera, or just create a mood. By careful manipulation, you can use lighting to create special effects.

Reflecting Pool

Reflected light can simulate various illusions, such as cars passing by, or a television flickering.

EXAMPLE:
Fool the viewer into thinking you're shooting next to a lake or pool by shining light on floating aluminum foil to create a reflection.

TOOLS & PROPS:
Camcorder, tripod, large pan, aluminum foil, a bright light

STEP BY STEP:

1. Choose a location that isn't so bright that the lighting effect will get washed out. If shooting outside, set up in the shade.

2. Set up your camcorder on a tripod about three or four feet from your TALENT.

3. Fill a large pan with water, and place it next to the camcorder.

4. Tear a sheet of aluminum foil into two inch squares and float the pieces on the water.

5. Shine a light onto the floating foil so it reflects onto your subject.

6. Frame the shot of your talent, being careful not to show the pan of water. Add or subtract light to maximize the effect.

7. Adjust white balance and focus.

8. Instruct an assistant to gently move the pan—just enough to produce a slight rippling effect.

9. Press "start," cue TALENT, and shoot your waterside scene.

10. Press "stop" when the scene is over.

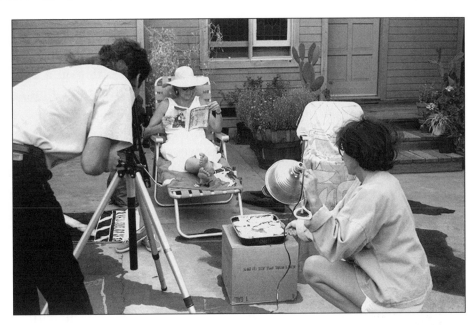

When you playback the tape, the bright rippling reflection will seem to be coming from a large body of water.

APPLICATIONS:
This effect can add realism to other tricks such as BOAT RIDE. Invent an action packed waterside adventure, or create the illusion that your TALENT is sunbathing—even in the coldest winter month.

Let There Be Light

Sometimes light itself is part of the content of the scene. For instance, suppose your scene calls for someone to walk into a room and turn on a table lamp. This may sound simple enough, but it can be a problem to shoot.

If a lamp is bright enough to light the whole scene, the camcorder won't be able to handle the intensity when it is switched on. You could damage your tube if your camcorder has one. If the lamp is low enough wattage to shoot, it won't be bright enough to light the scene properly. The solution lies in rigging auxiliary lights to turn on when your TALENT flicks on a prop table lamp.

EXAMPLE:
Coordinate a prop lamp on the set with supplemental lighting by using a power strip.

TOOL & PROPS:
Camcorder, tripod, table lamp, auxiliary lights, extension cords, a power strip

STEP BY STEP:

1. Create your set including the prop table lamp.

2. Set up your camcorder on a tripod, and frame a shot including the TALENT and the table lamp.

3. Light the scene as it should look with the table lamp off. Remember, a camcorder takes more light to see something than your eyes; though you might be able to see with the lamp off, you may need to add more light for the camcorder.

4. Install a low wattage bulb (20-30W) in the table lamp that you are using in the scene, and turn on the lamp.

5. Add more light to the scene (in addition to the lighting you provided in step 3-4) to make it look as it should after the TALENT turns on the table lamp. Light from outside the frame, and don't direct lights toward the camcorder.

6. Take the cables for all the lights that you added in step 5, along with the cord for the table lamp, and plug them into the power strip. When you switch on (or plug in) this power strip, the prop lamp and auxiliary lights should light up simultaneously.

7. Practice the moment where the light is switched on with your TALENT to get the timing right.

> "... show someone turning on a flashlight or lighting a lantern ..."

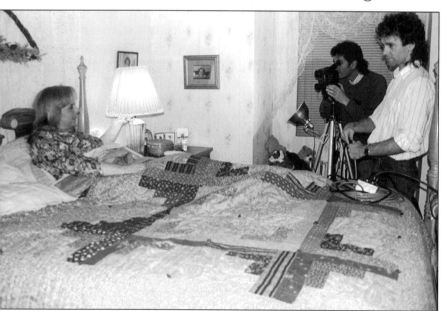

8. Press "start" and cue the TALENT.

9. As your TALENT turns on the table lamp, cue an assistant to switch on (plug in) the main power strip.

10. Finish the scene, then press "stop."

On playback, it should look as though the table lamp is lighting up the room.

APPLICATIONS:

Use a variation of this trick to show someone turning on a flashlight or lighting a lantern. If your scene calls for the lights going out, you can try this trick in reverse: emphasize the action of blowing out candles or create the sense of a power outage.

Altered Images

Video is a perfect medium for documenting people, things and events. Because a video image can show it "like it is," video is used for evidence in courts, it's used to document possessions for insurance purposes, and it is even used to show houses for sale. When "like it is" is not what you want, then you can experiment with altering the video image.

Video Feedback

At least once in your life, you've probably had the unpleasant experience of hearing a loud, high pitched, annoying squeal while attending a concert or listening to someone make a speech. That is audio feedback. To put it in simple terms, it occurs when sound coming out of the speakers gets picked up again by the microphone. It's then sent out through the speakers only to be picked up again by the microphone. This cycle continues, creating a loop. The squeal that results is an audio technician's nightmare.

While everyone has some awareness of audio feedback, few realize that there is also a similar phenomenon in video; not surprisingly, it's called video feedback. Fortunately, video feedback is not as intrusive as audio feedback. In fact, it can actually create some very interesting images.

Jimi Hendrix and countless others in the 60s tried to find ways to use audio feedback creatively and artistically. In much the same way you can be creative with video feedback effects. All you need to produce them is your camcorder and a TV monitor. A black and white set will work, but a color set will provide more spectacular effects.

EXAMPLE:
Create flashy, psychedelic images by setting up a video feedback loop on a character generator image.

TOOLS & PROPS:
Camcorder, tripod (optional), TV monitor

STEP BY STEP:
1. Set up a TV monitor.
2. Turn down or mute the volume to assure that you don't produce any *audio* feedback.

3. Set up your camcorder on a tripod about three to five feet from the TV monitor at the same height as the center of the screen. (You may perform this trick hand-held, but a tripod will provide more control over the effects you can create.)

4. Connect your camcorder to the TV monitor so that you can see the image from your camcorder on the TV.

5. Aim your camcorder at the TV monitor and frame a shot of the screen.

6. Press "start," and put a few C.G. letters on the screen.

"It can resemble the amorphous flow of a lava lamp, or pulsate like a strobe light."

As the video signal loops between the camcorder and the TV monitor, the image on the screen should start to react. Video feedback can take many forms. It can resemble the amorphous flow of a lava lamp, or pulsate like a strobe light. But that's just the beginning.

Try panning the camcorder slightly to the left and right. Try tilting up and down, and zooming in and out. Move the focus from one extreme to the other. Each time you change one of these parameters the effect will change. Watch what happens when you raise or lower the camcorder height or move the whole tripod forward, back, or at a slight angle to the screen. Even changing the white balance setting will alter the effect.

You can also add outside objects to the loop. Put your hand or other object between the camcorder and the screen. Try to come up with other creative ideas and keep experimenting. You're sure to stumble upon some truly remarkable effects.

APPLICATIONS:
Now that you know how to create video feedback, you can use it to enhance your videos. It is a terrific way to add pizzazz to titles or credits. I guarantee your audience will be impressed. As you'll see when you experiment, video feedback can produce many different special effects. Take note of how feedback can be controlled, and use the effects that suit your needs.

SPECIAL EFFECT

31

Homemade Filters

Some camcorders have their own set of internal filters, which are designed to help reproduce colors accurately. External filters (placed in front of the lens) can add a whole new dimension to your video. These filters affect light as it passes through them to alter the final image.

You can purchase filters if you want (from star filters to those that offer a kaleidoscope effect), but you can also make some filters using household items.

EXAMPLE:
Using a colander as a video filter.

TOOLS & PROPS:
Camcorder, tripod, colander

STEP BY STEP:
1. Set up your camcorder on a tripod.
2. Frame a shot of whatever subject you choose.
3. Adjust lighting, white balance and focus.
4. Hold a colander in front of your camcorder lens, press "start," and record your subject through the colander holes.
5. When you have finished videotaping your scene, press "stop."

"External filters ... can add a whole new dimension to your video."

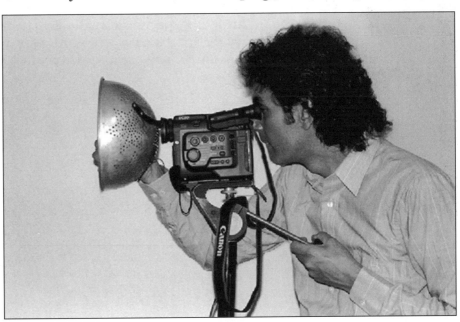

As you record, the video results will be altered by the colander as it partially blocks the light.

APPLICATIONS:

"... add unique, mystical ... and artistic flair to your home videos."

Using clothes pins, duct tape or rubber bands, you can support other homemade filter items. Try repeating steps 2-5 with some of the item ideas listed below:

- plastic wrap
- a glass
- a loosely woven basket
- light colored plastic
- a glass bowl
- a small-leafed bush or plant
- a fairly clear plastic cup
- aluminum foil with a pattern of holes punched out
- cardboard with a design cut out
- sunglasses
- binoculars
- a kaleidoscope
- a piece of stained glass
- a piece of window screen
- a fish net
- a bottle
- a sheer stocking

You can use these filter effects to add unique, mystical, romantic, intriguing, psychedelic and artistic flair to your home videos. As you try different items, keep an open mind. Write down the ones that you like so you can use them when you need them. Happy filtering.

Using Mirrors

Long before the magic of video, magicians roamed the earth entertaining and bewildering people by making birds appear and coins vanish. One item sure to be found in their bag of tricks was a mirror. Every mirror, by it's very nature, has a little magic of its own.

Little Window

Mirrors can magically add frame-in-a-frame technology to a home video scene without additional expensive equipment.

EXAMPLE:
Use the simple principle from NOW YOU SEE IT, NOW YOU DON'T (page 9) to introduce a window over the newscaster's shoulder to bring up a live interview.

TOOLS & PROPS:
Camcorder, tripod, news desk and props, a square or rectangular mirror with straight edges and a thin plain frame

STEP BY STEP:
1. Set up the news desk and add props to make your scene look like a television news set.

2. Position TALENT A (the newscaster) at the news desk.

3. Hang the mirror on the wall behind and just over the shoulder of TALENT A.

4. Set your camcorder up on a tripod at a slight angle from the news set. (*See diagram*)

5. Frame a shot including the desk top, TALENT A, and the mirror. Lock down the camcorder.

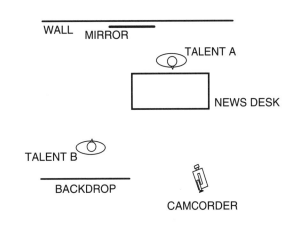

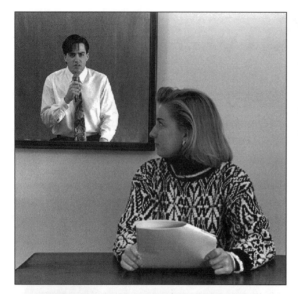

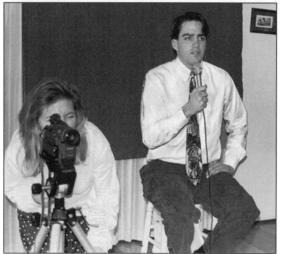

6. Locate the spot in the room that the camcorder sees through the mirror, and position TALENT B there.

7. Create the desired lighting and background for TALENT B.

8. Adjust lighting, white balance and focus.

9. Instruct TALENT A&B to remain in position and take the mirror off the wall.

10. Press "start" and cue TALENT A.

11. TALENT A (the newscaster) speaks: "Things were jumping at City Hall tonight. For more on that story we go to City Hall."

12. Press "stop" and cue TALENT A to freeze.

13. Place the mirror back on the wall.

14. Press "start" and cue TALENT A to turn around and looks toward the mirror.

15. TALENT A speaks: "Dan, what's the situation?"

16. TALENT B (Dan) speaks: "Well, Jane, the situation here at City Hall is..." (Dan and Jane discuss the details of the situation. When it is over, Dan cues Jane with) "...Back to you, Jane..."

17. TALENT A speaks: "OK, Dan, thanks for that story."

18. Press "stop" and cue TALENT A to freeze.

19. Remove the mirror from the wall.

20. Press "start,"cue TALENT A to resume the newscast.

21. Press "stop" when the newscast concludes.

If the camcorder and the newscaster remain relatively motionless during the pause and the mirror is placed back in the exact same spot, this trick should create the illusion of a video window appearing above the newscaster's shoulder. When the tape is played back, it'll look like Dan is reporting from some remote location through an electronic video feed.

APPLICATIONS:

Aside from having fun putting together your own comedy newscasts, this is a great way to send a "live" message via videotape. You could also use the "little window" as someone's conscience or guardian angel.

Hand Mirror

By holding a small hand mirror in front of your camcorder lens, you can create the effect of a split screen. This trick is easier to do outside because you won't need to light two sets.

EXAMPLE:
Use a mirror to create a split screen.

TOOLS & PROPS:
Camcorder, tripod, hand mirror with plain, straight edges (no frame)

STEP BY STEP:

1. Place camcorder on a tripod about $3\frac{1}{2}$ feet high in a well lit area.

2. Position TALENT A on a chair directly in front of your camcorder, facing the lens and sitting as still as possible.

3. Frame a close-up shot of TALENT A so that he or she is on the right half of the screen.

4. Adjust white balance and focus. Use manual focus; autofocus will be fooled by the mirror.

5. Position TALENT B on a chair to the left of your camcorder, the same distance from the lens as TALENT A (*see diagram*).

6. Hold the mirror up against the front of your camcorder's lens to form a vertical line down the center of the screen.

7. While holding the edge of the mirror firmly against the lens rim, pivot the mirror until TALENT B is on the left of the split screen.

Don't Scratch Your Lens...

Make sure your camcorder lens has a rim or collar in place to protect it. Don't let the mirror touch the glass of the lens or the lens could be scratched.

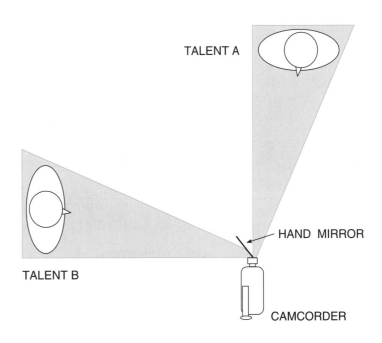

8. Cue TALENT (A&B) and press "start."

9. Shoot your segment and press "stop."

Both images will appear side by side, like a split screen. You may need to make minor adjustments to fine-tune this trick. When you feel ready, add dialogue or simple action.

APPLICATIONS:

Try to create one complete face from two people. Try sliding the mirror in and out. Try angling the mirror. Next time you are videotaping a Little League game, try splitting the screen to show the action on the field and the reaction in the bleachers.

Mirror on the Wall

Catch the viewer a little off guard by shooting the TALENT through a mirror, then zooming out to reveal the mirror.

EXAMPLE:

Add dramatic flavor to a videotape of your uncle's birthday party by shooting his reflection in a mirror, then zooming and panning to him.

TOOLS & PROPS:

Camcorder, tripod (optional), mirror on the wall

STEP BY STEP:

1. Position your camcorder so that you can see the TALENT (your uncle) through the mirror, and zoom in and focus on him through the mirror. Don't show the mirror frame.

2. Adjust lighting and white balance.

3. Press "start" and begin recording.

4. Zoom out slowly to show the mirror frame, then pan toward the TALENT.

5. Hold that long shot for a few seconds and press "stop." Continue filming the party.

On playback, the audience won't realize they are viewing the TALENT through a mirror until the edges of the mirror are revealed. This can create an interesting addition to your party film.

APPLICATIONS:

Use this technique as a way to spice up any scene where a mirror is present. If there is no mirror, consider using the reflection from a window or glass door.

Collage

An exciting video effect can be achieved by producing a collage of shots. Your collage can be made up of individual still photos or a series of video images.

Photo Collage

You can transform a series of your favorite still photos into a sophisticated, edited video segment. Using photos for your collage allows a lot of versatility. You'll need a camcorder that has the ability to focus on objects very close up. How many photos you use and how long you shoot each one depends on the mood you want to create.

EXAMPLE:
Use photos from your last vacation to create an exciting photo collage of the trip.

TOOLS & PROPS:
Camcorder, tripod, table, vacation photos

STEP BY STEP:
1. Gather up all the photos from your last vacation and put them in the order you want.
2. Set your camcorder up on a tripod next to a table.
3. Aim the camcorder straight down toward the table surface. You

"... transform a series of your favorite still photos into ... a video segment."

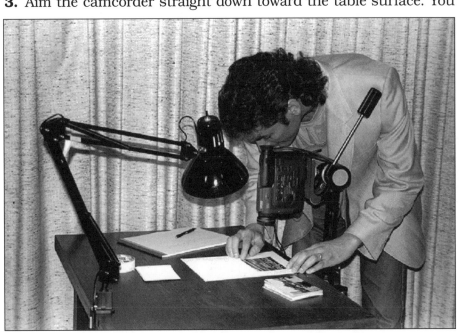

TILT LEVER

"A well made photo collage can make a perfect gift."

need to get the camcorder perpendicular with the table (*see diagram*). This is of critical importance because if the angle is off significantly, you won't be able to achieve sharp focus over the entire photo. If your tripod won't tilt far enough, you'll need to find a way to make the table perpendicular with the camcorder, or build a ramp on top of the table with books and cardboard.

4. Position the camcorder so the lens is anywhere between one and five inches from the table. The exact height will depend on your camcorder's lens and the size of the photo you're shooting. (You'll have a chance to adjust the camcorder height again in step 6.)

5. Position the first photo on the table directly under the lens.

6. Readjust the height of the camcorder to frame the shot of your photo.

7. Light the photo, adjust white balance, and focus. If you can't achieve a sharp focus, try adding more light. If that doesn't help, try readjusting the height of the camcorder again as in step 6.

8. Activate the fade function and press "start" to fade up from black.

9. Once the image is up and visible, count three seconds and press "stop."

10. Position the next photo.

11. Check the framing and focus. Readjust if necessary.

12. Press "start."

13. Count three seconds and press "stop."

14. Repeat steps 10 to 13 until you have recorded all the photos.

On playback, enjoy your video photo collage. If your camcorder is equipped with an audio dub feature, consider finishing off your collage by adding complimentary music. (*See note* "Adding Sound" on page 7.)

APPLICATIONS:

Try variations: fill the frame, or show the photo's edges; show one photo, or several photos together; show photos straight on, at angles, or overlapping. Try holding each shot for less or more than three seconds, or at increasing or decreasing rates.

Use this technique to tell a story: document family history; make a collage of your children, your parents, your pets or life's special events. A well made photo collage can make a perfect gift. It'll take some time, but you and your audience will be happy with the results.

Video Collage

Video collage creates the appearance of fast paced video editing. The key to a successful video collage is in the timing. The length of each shot is very important. A video collage is designed to bombard the viewer with a flutter of images. Only you can decide how long to hold each shot. Pace the shots too slowly, and you'll loose the effect.

EXAMPLE:
Make an interesting video collage of your own neighborhood.

TOOLS & PROPS:
Camcorder, tripod (optional)

STEP BY STEP:
1. Walk around the block to plan at least twenty interesting shots. Look for a mixture of long shots, medium shots, and close-ups. (Some suggestions: street signs, houses, cars, trees, dogs, fire hydrants, doors, hedges, flowers, schools, stores, parks, the neighbors.) Hand holding the camcorder will probably work best.

2. Choose and locate your first shot.

3. Adjust framing, white balance, and focus.

4. Press "start" to begin shooting.

5. Count to two and press "stop."

6. Locate your next shot.

7. Continue your walk around the block repeating steps 3 to 6 until you shoot twenty shots.

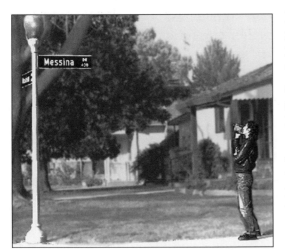

Don't hold any shot too long no matter how interesting it is. When you playback the tape, you should see a relatively rapid succession of shots. As you watch, you'll be able to critique your timing. Music or some other creative audio addition is an excellent way to add continuity and cohesiveness. (*See note* "Adding Sound" on page 7.) A good collage can be a lot of work, but it's worth the effort.

APPLICATIONS:
Create your own music video or *Saturday Night Live* style introduction. If you're shooting a wedding, you might start with shots of flowers, stained glass windows, cars entering the parking lot, etc. For your child's school play, take a shot of the family getting ready, then hopping in the car. Shoot the outside of the school, the backstage chaos, etc. It'll make a great intro to your video.

Special Projects

When you bought your camcorder, you probably only thought you would be recording your children or documenting your vacations. Here are some other ideas for fun and relaxation.

Relaxation Video

You've heard of easy listening music. That's the stuff they play in the waiting room of the dentist office. It's supposed to relax you, but it's hard to relax looking across the room at other nervous people who are staring at you, thinking about how nervous you look.

In some situations you may find it relaxing to close your eyes and erase all the visual stimulation. However often images creep in and take over to fill the void. Relaxation video goes one step further than easy listening, because it provides a wonderfully relaxing experience by occupying both your eyes and ears. (*See note* "Adding Sound" on page 7.)

EXAMPLE:
Create your own homemade relaxation video by videotaping a fish tank.

TOOLS & PROPS:
Camcorder, tripod, fish tank (or other peaceful view), music

STEP BY STEP:

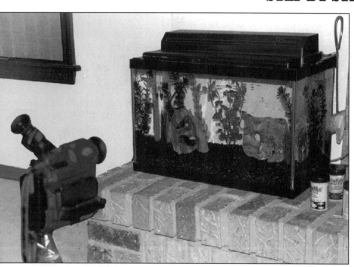

1. Pick out some music that you find relaxing—enough to last for one hour. Whether you're using records, tapes, or CDs, make sure you can change the music quickly and keep the interruptions short.

2. Find a fish tank that you can videotape.

3. Set up your camcorder on a tripod and aim it directly at the fish tank.

4. Adjust the lighting in the room to eliminate glare from the glass.

5. Frame a shot to fill the screen with the fish tank.

6. Adjust white balance and focus. Don't use auto-focus, it may shift the focus when a fish swims by; that would not be very relaxing.

7. Press "start" to begin recording.

8. Start the music.

9. Keep the music going, keep the fish happy and let the video roll for an hour.

10. Press "stop."

When you playback the tape, you can watch the tranquil scene of fish swimming to-and-fro. Relaxation videos seem to have a special calming effect on the viewer and can actually reduce stress. They make great gifts but don't forget to keep one for your own stress reduction.

APPLICATIONS:
Try to think of other peaceful images you can use such as gently falling snow, a beautiful sunset, a crackling fireplace, or even a screen saver program on a computer screen. If you're near an ocean, you can simply set up your camcorder and tripod at the beach and tape the crashing surf. Some of these options provide excellent, mesmerizing live sound, so you won't need to add any music.

Shooting at the Beach...
If you choose the beach option, be sure to mount your camcorder safely on a tripod. You don't want to get any sand or water on your camcorder—it won't like it. Plan for the rising tide and stay near your camcorder—a lot can happen in an hour.

Talk Show

For three decades, Ed McMahon delivered the familiar words "Here's Johnny!" into America's hearts and homes. Now that Johnny Carson has retired, he leaves behind an American legacy: the television talk show. Although television has seen many changes in technology, tolerance and topics, the basic formula for the TV talk show has remained pretty much the same. Using this tried and true talk show formula, you can have fun producing your own program.

EXAMPLE:
Utilize a talk show format to create your own improvised talk show.

TOOLS & PROPS:

Camcorder, tripod, a few chairs, desk, plant, coffee cup

STEP BY STEP:

1. Pick a good background for your set, such as a decorative wall or window.

2. Position the host's desk and chair and a couple of guest's chairs (see photo).

3. Add some props to set the scene.

4. Set your camcorder up on a tripod about ten feet away from the host's desk. Frame a shot of the entire set to establish the scene.

5. Position TALENT in the chairs.

6. Practice some of the various shot possibilities:
 - Close-up of the host
 - Close-up of the guest
 - Medium shot of both host and guest
 - Long shot of entire set

7. Adjust lighting, white balance and focus.

8. Press "start," and cue TALENT. As you shoot, follow the conversation. For example, zoom into a close-up of the host, then pan over to the guest, then zoom out to a medium shot of both.

9. When they go to commercial, press "stop."

"... you'll have your very own homemade talk show."

To keep things moving, prepare a list of questions for the host to ask. The guests can be themselves, or play character roles. When you play back the tape you'll have your very own homemade talk show.

APPLICATIONS:

Aside from being a terrific way to spend a playful evening with friends, it can be a creative way to bracket presentations or performances. If you want to tell about changes in your life (a new baby, new job, or new home), try being the guest on a homemade talk show so you can tell it all. If you videotape your child's latest dance routine, you can easily turn it into an appearance on a homespun talk show. Create a show jingle and even work out a monologue. When friends come over, don't watch TV, make TV.

Boat Ride

If a scene calls for a boat ride, you can run down to the local marina and rent a boat. You'd better make that two boats; you'll need one to shoot, and one to shoot from.

Renting boats and shooting on the water would be the most realistic way to approach the shoot. But if your budget convinces you to compromise on realism, another option is to simulate a set and the motion of the waves by rocking your camcorder. Involve the children in this one.

EXAMPLE:
Use background illusion and a tripod tilt lever to simulate the rocking motion of a boat at sea.

TOOLS & PROPS:
Camcorder, tripod, blue background, large pieces of cardboard, tape, an oar (or a broom)

STEP BY STEP:
1. Pick a background that seems vast, and looks like the sky above the open ocean: use a solid blue wall, or simply hang a blue sheet. (See PROJECTED BACKGROUND ILLUSIONS for more ideas.)

2. Remove all furniture, paintings, or anything that would interfere with the illusion.

3. Using cardboard and tape, construct your simulated boat. Don't worry about trying to make the boat too authentic looking: this illusion is already limited by other factors like the background and the lack of water.

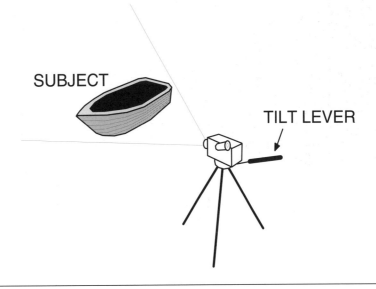

SUBJECT

TILT LEVER

4. Mount your camcorder on a tripod so the camcorder is facing the boat with the tilt lever to the side. When you operate the tilt lever, the camcorder should tilt from side to side. (*See illustration in* DEFY GRAVITY, page 60.)

"... the boat is rocking back and forth in the swells of the ocean."

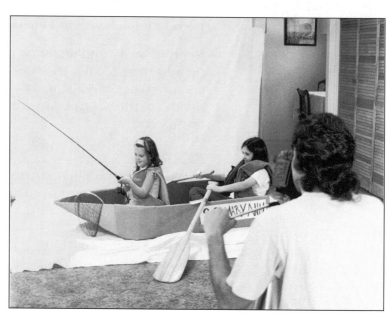

5. Instruct your TALENT to sit in the boat.

6. Give the TALENT a prop to use for an oar.

7. Frame a shot of your subject. Be sure not to include anything that could ruin the illusion, such as a window or door in the background.

8. Adjust lighting, white balance and focus.

9. Slowly rock the camcorder from side to side with the tilt lever to simulate the motion of the waves.

10. Cue the TALENT to row.

11. Press "start" and begin your boat simulation.

12. Play out the scene; then press "stop."

On playback, it'll appear as if the boat is rocking back and forth in the swells of the ocean. Resist adding additional objects to the background such as birds or clouds; when the camcorder tilts back and forth, these items will rock as well. Clouds and birds don't do that.

APPLICATIONS:

This is a delightful way to entertain your children and their friends. Create a seafaring adventure story, or fabricate a fisherman's tale. It won't look as realistic as Hollywood movies, but it'll be "reel" fun!

Personal News

You can create a video segment and slip it into a real broadcast. If you do it right, you can fool your audience into believing they're watching regular TV. This is a great way to make an announcement or deliver a message.

EXAMPLE:
Give a surprise birthday greeting with a personalized news cast.

TOOLS & PROPS:
Camcorder, tripod, VCR capable of taping off air, birthday cake

STEP BY STEP: (In Three Parts)

Part 1

1. Set up your VCR to tape a local news program.

2. Playback the program and carefully choose a place to insert your custom-made news segment. Finding just the right spot is key to this trick. Pick a spot where the newscast cuts to another reporter "on the scene."

3. Leave the tape at the spot you want to place your news insert and put it in your camcorder. (If your camcorder is a different format than your VCR, copy the news program onto your camcorder from the VCR. Consult your manual for instructions.)

"... create a video segment and slip it into a real broadcast."

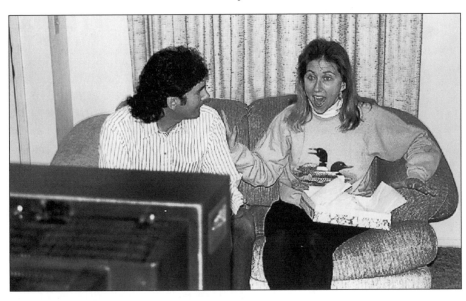

Part 2

4. Create a believable set for your custom report with backgrounds, costumes, and props.

5. Set your camcorder up on a tripod.

6. Make sure your tape is exactly cued so that you don't cut off the newscaster (*See* the note about "Camcorder Timing" on page 43), and put the camcorder on record/pause.

7. Position your TALENT (the reporter) in front of your background.

8. Frame a shot of your TALENT.

9. Adjust lighting, white balance and focus.

10. Press "start" and cue your TALENT.

11. Instruct the TALENT to deliver the news message: "I'm standing outside [such-n-such] where negotiations are currently taking place. Before I get into that, on behalf of everybody here, I want to say Happy Birthday to [*your birthday guest's name*]."

12. Press "stop."

The rest is fun. Invite Susan or Sam So-n-So over on her/his birthday and play the tape. Turn on the video as you turn on the TV. He or she will just think they are watching TV—until they hear their personalized message. Serve cake.

APPLICATIONS:
Aside from wishing someone "Happy Birthday" you can use this trick to welcome visitors, congratulate a friend, announce a surprise or even to make a marriage proposal.

Through the Looking Glass

Remember the classic story where Alice walked through the looking glass into Wonderland? You can't walk through a mirror to achieve the same effect: that could prove to be messy and dangerous—and if it worked I'm not sure that anyone would be able to get you back. However, you can utilize the magic of video to produce a similar effect.

Linking two settings through video will do the trick. The settings must be different enough to represent significantly separate realities, such as: a congested city and the open country. By carefully orchestrating a link to join two scenes, you can convince your viewer that your TALENT has walked from one reality into another.

EXAMPLE:
Creating the mystical illusion of a person walking into a totally different reality. For the purposes of this example we'll choose your home in Anytown, USA, and the exotic reality of your next vacation.

You Need a Strong Contrast!

If you live somewhere exotic, like Waikiki Beach, this trick will only work if you vacation somewhere terribly dull and boring.

TOOLS & PROPS:

Camcorder, tripod, a vacation plan

STEP BY STEP: (In Two Parts)

Part 1

1. Before you go on vacation, arrange to videotape your traveling companion coming home from work or school. You can choose your spouse, your child – anyone who is going on your vacation.

2. Set your camcorder up on a tripod, and frame a long shot of your front door from the outside.

3. Adjust white balance and focus.

4. Press "start" and cue the TALENT (your traveling companion) to walk in the front door after a hard day, looking a little over-tired.

5. Press "stop," and bring the camcorder inside.

6. Frame a close-up of the TALENT's face.

7. Adjust lighting, white balance and focus.

8. Press "start" and cue the TALENT.

9. TALENT speaks: "I wish I could escape all this."

10. Press "stop."

11. Frame a shot of the front door so that you can't see the outside when the door is opened. If this is not possible with your front door because of a long hallway or obstruction, use another door.

12. Adjust lighting, white balance and focus.

13. Press "start" and cue the TALENT to turn and walk out the door.

14. As soon as the TALENT is half-way out the door press "stop" and cue TALENT to freeze.

15. Set up your camcorder outside, and frame a long shot of the door area. Adjust focus and white balance.

16. Press "start" and cue the TALENT to resume walking toward you, out the door, looking delighted at what he or she sees.

17. Press "stop."

18. Turn off your camcorder and pack it for the trip. Also pack whatever your TALENT was wearing (you'll need the "costume" to finish the shot).

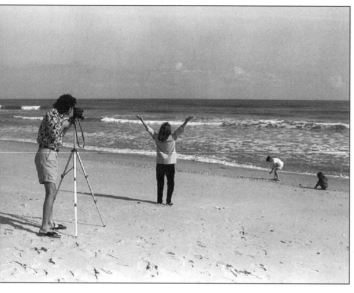

Part 2

19. When you get to your vacation spot, take out your camcorder and bring your TALENT, dressed in the same clothing, to a scenic spot.

20. Set your camcorder on a tripod (see the caution on page 108, if shooting on the beach).

21. Frame a long shot of the TALENT from behind, with the vacation setting as a background.

22. Adjust white balance and focus.

23. Play the tape up to the spot where you "stopped" it in step 17 and put your camcorder into the record/pause mode. Make sure the tape is in exactly the same spot. (*See note* "Camcorder Timing" on page 29.)

24. Press "start" and cue the TALENT to reenact the same gestures and expression of amazement as in step 16.

24. Press "stop."

Continue shooting your vacation. When you play the tape, your traveling companion will have stepped through the looking glass.

APPLICATIONS:

Use this trick as a way to introduce your next vacation video. It can be used to create a fantasy landscape for your new home, develop a satire about your new office, or weave a magical tale for children.

Video Theater

By coordinating carefully planned pauses in the video with rehearsed lines from a planted audience member, you can create two-way communication between the video and the audience.

EXAMPLE:

Create the illusion that a person in your video is interacting with an audience member who is having difficulty hearing.

TOOLS & PROPS:

Camcorder, tripod, an audience

STEP BY STEP: (In Three Parts)

Part 1

1. Pick a person to host your video (TALENT A).

2. Set up your camcorder on a tripod.

3. Frame a shot of TALENT A.

4. Adjust lighting, white balance and focus.

5. Press "start" and cue TALENT A.

6. TALENT A speaks: (in a quiet voice) "Good afternoon ladies and gents. I'm glad you could all make it to our presentation today."

7. TALENT A pauses and looks off to his or her left as if listening to someone for about 3 seconds.

8. TALENT A resumes in a louder voice: "I'm sorry, I'll try to speak up. Good afternoon and welcome to today's presentation." (She continues with material for your program.)

9. Press "stop." This part is done. Put the tape in a safe place.

Part 2

10. Find a second person with a bit of acting ability to use as a plant in the audience (TALENT B).

11. Show the tape you created in steps 1-9 to TALENT B.

12. When TALENT A pauses in the video, instruct TALENT B to yell out "Louder, we can't hear you!"

13. Allow TALENT B to practice his role until he feels comfortable with the timing.

Part 3

14. Arrange to show the video to an unsuspecting audience.

15. Position TALENT B in the appropriate area of the room. In this case, TALENT B should be to the right side of the monitor since that's the direction TALENT A looks (in step 7).

16. Play the tape and amaze your audience as TALENT B interrupts and TALENT A (the host on the video) appears to respond and interact with TALENT B.

APPLICATIONS:

Spice up a boring video presentation at your job. Create an interactive holiday video. Bewilder children at a birthday party. This trick was used in Woody Allen's *Purple Rose of Cairo* when Jeff Daniels spoke with Mia Farrow from the movie she was watching. In *Jurassic Park*, Richard Attenborough talks to himself on a movie screen. Now you can use it in your own home video.

Glossary

Ad-lib. Improvised; performed without a script.

Autofocus. Camcorder feature designed to focus the picture automatically.

Background. The area behind the subject.

Back Lighting. Light from behind the subject.

Barn Door. A flap or blinder that is used to mask lighting.

Camera Angle. Angle from which a shot is taken.

Close-up. View of a subject from a short distance.

Cut (cutting). Abrupt transition from one scene to another.

Depth of Field. The depth of the area in which objects in the frame will be in clear focus.

Dolly Shot. Movement of camcorder position as opposed to a pan, tilt, or zoom.

Dub. To add or change the sound of a recorded video.

Fade In. A gradual transition from black (or white) to a picture.

Focus Ring. The ring on the lens collar used to control the focus manually.

Foreground. That which is in the front portion of the picture, or in front of the subject

Frame. The image in the camera's view. To compose a shot with a viewfinder.

Generation, Going Down a. Loss of quality that results from copying (editing) video-taped images.

Hand-held. Supporting the camcorder without a tripod.

Long Shot. View of a subject from a long distance.

Medium Shot. View of the subject from the waist up.

Monopod. One legged camera support, easier to move than a tripod.

Pan. A horizontal camera pivot.

Subject. The main person or object you are videotaping, generally what your camcorder is focused on.

TALENT. Actor or actress performing in your video.

Telephoto. A long focal length used to gain a close-up perspective. Often referred to as "Zoomed In."

Tilt. A vertical camera pivot.

Tripod. A three legged stand designed to support a camcorder.

VCR. Video cassette recorder.

Viewfinder. Camcorder eyepiece used to monitor and frame video images.

White Balance. A built-in system designed to enable adjustment for different lighting conditions.

Wide Angle. A short focal length used to gain a wide perspective, often referred to as "Zoomed Out."

Zoom In. To change the lens to a telephoto position; close-up.

Zoom Out. To change a zoom lens to a wide angle position; long shot.

Index

Other Books from Amherst Media, Inc.

The Beginner's Guide to Pinhole Photography
Jim Shull

Take pictures with a camera you make from stuff you have around the house. Develop the results at home! Pinhole photography is fun, inexpensive, educational and challenging. $17.95 list, 8½x11, 80p, 55 photos, charts & diagrams, order no. 1578.

How to Shoot and Sell Sports Photography
David Arndt

A step-by-step guide for amateur photographers, photojournalism students and journalists seeking to develop the skills and knowledge necessary for success in the demanding field of sports photography. $29.95 list, 8½x11, 120p, 111 photos, index, order no. 1631.

Handcoloring Photographs Step-by-Step
Sandra Laird & Carey Chambers

Learn to handcolor photographs step-by-step with the new standard handcoloring reference. Covers a variety of coloring media. Includes colorful photographic examples. $29.95 list, 8½x11, 112p, 100+ color and b&w photos, order no. 1543.

Basic 35mm Photo Guide
Craig Alesse

Great for beginning photographers! Designed to teach 35mm basics step-by-step. Features the latest cameras. Includes: 35mm automatic and semi-automatic cameras, camera handling, f-stops, shutter speeds, and more! $12.95 list, 9x8, 112p, 178 photos, order no. 1051.

Special Effects Photography Handbook
Elinor Stecker Orel

Create magic on film (or even video) with special effects! Step-by-step instructions guide you through each effect, using things you probably have around the house. $29.95 list, 8½x11, 112p, 80+ color and b&w photos, index, glossary, order no. 1614.

Family Portrait Photography
Helen Boursier

Tells how to operate a successful portrait studio, including marketing family portraits, advertising, working with clients, posing, lighting, and selection of equipment. $29.95 list, 8½x11, 120p, 123 photos, index, order no. 1629.

Lighting Techniques for Photographers
Norm Kerr

This book teaches photographers and videographers to predict the effects of light in the final image. It covers the interplay of light qualities, as well as color compensation and manipulation of light and shadow. $29.95 list, 8½x11, 120p, 150+ color and b&w photos, index, order no. 1564.